An
Italic Calligraphy
Handbook

Caroline Joy Adams

DOVER PUBLICATIONS, INC.
Mineola, New York

ACKNOWLEDGMENTS

Grateful acknowledgment is made here to: All the calligraphers who generously allowed samples of their work to be reproduced in this book; The Houghton Library, Department of Printing and Graphic Arts, Harvard University, for permission to use a page from The Cataneo Manuscript, which was reproduced by Taplinger Publishing Co., in *An Italic Copybook; The Cataneo Manuscript* in 1981; Charles Scribner's Sons, for use of calligraphy by Jeanyee Wong from the *1986 Wyeth Calendar*, ©1985 Charles Scribner's Sons; Dover Publications, for permission to reproduce illustrations from *Three Classics of Italian Calligraphy, Ornamental Penmanship*, and *Arthur Baker's Renaissance Copybook*; John Neal, for permission to use Jerry Kelly's "Making of Letters" quote, which was created as a keepsake for the Letter Arts Book Club in 1983; Faber & Faber Ltd., for permission to use illustrations from Alfred Fairbank's *A Handwriting Manual*. A special thank you is also extended to: all the students who have been in my classes at Harvard University, Tufts University, and the Massachusetts Institute of Technology, whose input has been invaluable; the staff members of Gnomon Copy Center at 99 Mt. Auburn Street, Cambridge, for constant cooperation; Jerry Kelly; the staff members of Type for U, Cambridge, for doing an excellent job; and to Barbara Holdridge of Stemmer House Inc., for her support of this project.

Copyright

Bibliographical Note

This Dover edition, first published in 2004, is an unabridged republication of the work originally published by Stemmer House Publishers, Inc., Owings Mills, Maryland, in 1985. For the present edition, the conclusion on p. 94 has been revised and a new section, "Helpful Resources & Calligraphic Websites" has been added.

Library of Congress Cataloging-in-Publication Data

Adams, Caroline Joy.
 An italic calligraphy handbook / Caroline Joy Adams.
 p. cm.
 "This . . . is an unabridged republication of the work originally published by Stemmer House Publishers, Inc., Owings Mills, Maryland, in 1985. For the present edition, the conclusion . . . has been revised and a new section, 'Helpful Resources & Calligraphic Websites' has been added."—T.p. verso.
 Includes bibliographical references.
 ISBN 0-486-43528-8 (pbk.)
 1. Writing, Italic. 2. Calligraphy. I. Title.
Z43.K74 2004
745.6'1977—dc22

 2004041360

Manufactured in the United States of America
Dover Publications, Inc., 31 East 2nd Street, Mineola, N.Y. 11501

Dedicated to my parents

Arvid Knudsen
and Lynne Knudsen

Rudolf Koch:

THE MAKING
OF LETTERS

in every form is for me the purest
and the greatest pleasure, and at
many stages of my life it was to
me what a song is to the singer, a
picture to the painter, a shout to
the elated, or a sigh
 to the oppressed.

Jerry Kelly

CONTENTS

INTRODUCTION

The word calligraphy, literally translated from the Greek, means beautiful writing. It refers not to one particular style, but to an enormous range of styles, which may be written with a variety of tools. The aim is not only to communicate ideas and information, but to do so in an aesthetically pleasing manner.

The most popular style in use today is the Italic, to which this book is devoted. One major reason for its popularity, aside from its inherent attractiveness, is that it is really the *only* all-purpose style, suitable for the most formal documents when written slowly and carefully, and for everyday handwriting when written more quickly and freely.

Learning to write Italics may well be likened to learning to play a musical instrument. You would not be likely to master flute, piano, guitar or trumpet if you tried learning them all at once; nor could you master four or five lettering styles at one time. Once one style can be written with ease and confidence, however, others may more easily follow. In many other ways, as well, learning calligraphy can be compared to learning music. Disciplined freedom is certainly the essence of both. A certain amount of time must be spent in the beginning, practicing in a disciplined, systematic way, until the hand is trained to form certain patterns easily, and—in the case of calligraphy—the eye is trained to really "see." The greater the initial discipline, the greater are the possibilities for creativity and freedom of expression later on. Calligraphy can be a deeply satisfying means of artistic expression, and anyone willing to put in the necessary practice time, regardless of whatever his or her regular handwriting looks like, will be able to achieve pleasing results.

The Italic style originated in early fifteenth-century Italy, where it developed and matured, reaching its highest state of popularity and perfection in the sixteenth century. Ultimately it evolved into the Copperplate style, which became the style of cursive writing taught in schools in this century, as explained more fully in the History chapter of this book.

Italics has been revived in the twentieth century, in great part due to the efforts of the late English calligrapher Alfred Fairbank, who devoted much effort to the promotion of the style. Fairbank did a great deal of research into original fifteenth and sixteenth-century Italic, and wrote several books on the subject. Going back to the original sources is, without question, of vital importance in rediscovering the best methods of teaching and learning the Italic style; and it is in this respect, most of all, that this present book differs from any other current book on the subject. For no modern manual, as yet, has rivaled the simplicity, the beauty or the explicitness of instruction found in the best of the many manuals published in the sixteenth century by masters of the Italic hand. Having studied first-hand many of the early printed works on the subject, as well as original Renaissance manuscripts written in an Italic hand, I have aimed to create something of an updated version of these sixteenth-century manuals. The best ideas of each of the early masters have been taken, compiled and adapted into a unified whole, geared completely towards the modern reader.

While not making the false claim that it is *easy* to learn calligraphy, this book presents a method that makes it simpler to learn than any other known to the author. It allows the student to establish a simple, basic Italic style that then becomes a springboard for personal interpretations and variations.

Five aspects of the teaching method used here are as follows: the use of large letter models, the geometrical and detailed analysis of each letter, the use of the original stroke system along with illustrations of the letters in various stages of progression, the inclusion of ruled guidesheets, and finally, the presentation of groups of related letters for learning, rather than alphabetical order. All of these aspects are explained in detail below.

To begin with, the letter models in the Fundamentals chapter are of a rather large size. This has proven most helpful in allowing students really to see all the details of letter construction, which can easily be obscured when using a small pen size. Using a large pen to start off with was often recommended by the Renaissance masters, although for the most part, the models given were actually fairly small. However, Andres Brun, the Spanish master who published manuals in 1583 and again in 1612, showed in his books models of various sizes, some of which were *larger* than those presented here. The main bodies of his letters (a full letter "a," for example) were nearly one full inch in height.

Using large models, however useful and important this is, is certainly not sufficient in itself. Good large models must be accompanied by *exact instructions for following them*. While some books give good models, they fall short in explaining how to go about constructing the letters. In learning any other art, craft or science, it seems perfectly obvious that the more detailed the instruction, the greater likelihood that a successful result will be achieved, and this should apply to calligraphy as well.

The most important feature of this book, then, is the detailed geometrical analysis of the letter models, as evident in the models of Chapter Three. The letters are placed on guidelines showing their proper height, width, slant and pen angle. The most basic goal of all lettering is that it be well-balanced, which is really the same thing as rightly proportioned. After studying many models, the proportions that seem to give the most well-balanced, legible and pleasing effect have been chosen, and these are very closely related to the proportions of the letters of the Renaissance master Cataneo, particularly those illustrated in the sample of his work found in the History chapter of this book. By fitting the letters into the spaces provided, a good sense of proportion will be established. The eye and the hand will be trained to see and to produce well-proportioned letters, and this sense will remain even after such guidelines are dispensed with.

The idea here is not only to gain a good sense of proportion, but to understand thoroughly how these proportions are arrived at. Being vague is not helpful to a student. Being specific is. For example, horizontal strokes on the letter bodies must be brought a certain distance to the left before downward curves are begun, in order to avoid lopsided-looking letters. Knowing exactly where to begin curves enables the student to consciously and deliberately make well-formed letters. Without such guidance, it is simply trial and error, and it may well take a few hundred tries to come up with the right letterform, rather than the few dozen necessary when the student *knows exactly what he or she is aiming for and just how to go about achieving it*. Tracing over the letters at first, an exercise very much recommended here, as it was by the Spanish master Brun, is also very helpful. Tracing *alone*, however, may be like learning a speech in a foreign language. It may sound or look presentable at first, but if there is no understanding of the meaning behind it, it will most likely readily be forgotten. The type of analysis here has almost always been applied to the study of the Roman capitals, and all calligraphers know the importance of that. There is every reason, therefore, why Italics should be studied in the same way—*especially* because it is one of the more difficult calligraphic alphabets. The very first book to give instructions for writing Italics, Sigismondo Fanti's 1514 *Theorica et Practica*, gave excellent, detailed written instructions of this sort, which have never been surpassed. Unfortunately, however, the models of the letters were missing from his book.

In keeping with the detailed analysis of the letters, another aspect of the method of teaching here is to indicate how the letters are formed by showing them in different stages of their progression. The direction and sequence of strokes are not obvious to the beginner and must be shown explicitly. Fanti, Arrighi, Palatino, Brun and almost all the other Renaissance authors stated very clearly that most of the small Italic letters were to be made in one continuous stroke,

without lifting the pen. Although some scribes today successfully follow Edward Johnston's modern teaching of the technique of forming Italic letters in several strokes instead of one, students' attempts to do so are almost invariably stiff and lifeless, the very antithesis of Italic. Following the original teaching on this aspect of learning Italic is most important, as Alfred Fairbank also realized.

Another feature of this book is the inclusion of ruled guidesheets to be used with different pen sizes. This idea is neither original or modern. Almost all Renaissance masters ruled sheets for their students, and Andres Brun included full-sized guidesheets (slightly large than 9" by 12") in his books of 1583 and 1612. The early masters were aware of the fact that it is of far more importance that students spend time learning to form and arrange letters well than to engage in the tedious and difficult task of ruling straight lines on paper. While students of graphic design in art schools are certainly capable of ruling their own sheets, most beginners simply will not undertake this task, and will very likely end up using pre-ruled notebook paper instead, resulting in wrongly proportioned letters. Once proficiency in lettering is gained, time may be spent learning to rule lines, but in the beginning, having properly ruled sheets provided is an enormous help. Having 45° angle lines running across these pages at regular intervals as well is a tremendous help in gaining the critical 45° pen angle of Italics. Without the use of such lines, it may take months to attain the proper angle—or worse, it may *never* be attained. If, however, students have angle lines that can be used constantly to check the pen against at first, gaining and maintaining the angle proves to be *relatively* little trouble. Some may object that these devices are "crutches" and therefore should not be used. If, however, they give the student greater understanding of the subject, hasten the learning process and therefore lead sooner to disciplined freedom, skill, and enjoyment of the craft, such criticism hardly seems valid.

A fifth feature of this book that makes learning Italic as simple as possible is the grouping of related letters, rather than a progression in alphabetical order. This is a great help in seeing how the letters relate to each other, and gaining the sense of the alphabet as a family, or unified whole.

A book about beautiful writing should itself be beautiful to look at, page after page, whether type, calligraphy, illustrations or borders are used, separately or in combination. The Renaissance masters certainly strove to achieve this in their manuals, and this book as well aims to give the reader not only the ability to construct letters and arrange them well but to see them as part of overall beautiful design.

The simplicity of the models presented in this book reflects both Alfred Fairbank's view that models are better if they are pure calligraphy and do not show expressions of personality, and the author's desire to provide only a basis from which to begin a very personal journey into the creative possibilities of letterforms in general and Italic in particular. The last chapter of this book shows examples of the tremendous variety and individuality that are possible in the Italic style. These are examples of the freedom that comes as a result of the discipline. It is hoped that they will serve as one source of inspiration to the aspiring calligrapher.

This book may serve as a self-teaching manual and as a basic text for courses in calligraphy for students of all levels. Many advanced students may *intuitively* understand the principles of good proportion in Italic letters, but will find it helpful to see them explicitly demonstrated. To all who use this book, then, may the study of Italic bring you pleasure, and, in turn, enable you to bring pleasure and beauty to those around you.

Somerville, Massachusetts
March, 1985

Caroline Joy Adams

I

History

Auēdoti io deſcritto, Studioſo Let tor mio, l'anno paſſato un libretto da imparar ſcriuere littera Cãcellareſca, laquale, a mio iudicio, tiene il primo loco, mi parea integramente non hauerti ſatisfatto, ſe ancho non ti dimoſtraua il modo di accōciar ti la penna, coſa in tal exercicio molto neceſſaria, E pero in queſto mio ſecondo librecino, nel quale anchora a ſatisfattione de molti, ho poſto alcune uarie ſorti de littere(come tu uederai)ti ho uoluto deſcriuere al piu breue et chiaro modo che io ho poſſuto come tu babbi a temperarti detta penna.

De le uarie ſorti de littere poi, che in queſto Trattatello trouerai , ſe io ti uoleſſi ad una per una deſcriuere tutte le ſue ragioni, ſaria troppo longo proceſſo? Ma tu hauendo uolunta de imparare, ti terrai inanzi que ſti exempieti, et ſforcerati imitarli quanto poterai che in ogni modo ſeguendo quelli, ſe non in tutto, almeno in gran parte te adiutarano conſeguire quella ſorte di littera , che piu in eſſo ti dilettera. Piglialo adunque, et con felici auspicii ti exercita, che a chi uole conſeguire una uirtu niente glie difficile.

A BRIEF HISTORY OF THE ITALIC STYLE

The story of Italic begins in Renaissance Italy. The Humanist scholars of the early fifteenth century, becoming very much interested in early Greek and Roman writings, took upon themselves the task of copying out many of these manuscripts for contemporary usage. For some time there had been a growing dissatisfaction with the style of lettering then in common use, properly referred to as "Blackletter," but often today wrongly termed "Old English." These letters, beautiful though they can be, are densely packed together on the page, and can be somewhat difficult on the eyes in sustained reading. The Humanist scholars, therefore, decided to write out the new books in a more legible style. Poggio Bracciolini (1380-1437), who did much to promote new manuscript production, is generally credited with bringing about this change of lettering styles. He took as his models the rounded, pleasing letterforms of the Carolingian period, and these ninth century letters, in a somewhat revised version, became widely used in the copying of texts in the early 1400s. Then referred to as "Lettra Antiqua," today the term "Humanist" is used for these letters.

The early Italic style really began to take shape not long after, when another Humanist scholar, bibliophile and friend of artists, Niccolò Niccoli (1363-1437), took the Humanist letters one step further. He wrote a more rapid version of them, and certain changes began to occur. As the hand moves rapidly along, upright circles tend to transform themselves into slanted ovals. The letters often begin to lean in the direction of writing, and letters tend to join each other, or run together, when written more quickly. Niccoli, then, established the basic characteristics of Italic.

His style, used for personal correspondence as well as the writing out of manuscript books, quickly spread throughout Italy. This Humanistic Cursive (the word cursive deriving from the Latin root for running), really began to develop as a separate style in the 1420s. By the 1440s, it had come to the attention of the Vatican Chancery, and was adopted as the official hand for writing out those documents known as briefs. From this usage, the style began to acquire several new names, including "Cancelleresca," meaning Chancery, as well as "Littera di Brevi," designating its particular use in writing out briefs.

Two similar but slightly different styles of Italic began to emerge. In one, the ascenders of the letters were initiated with a slight upward diagonal stroke on the left side of the vertical, which may be called a serif. This is a natural continuation of the Humanist letterforms. Niccoli's own version of Italic, however, more often used a kerned projector to the right side of the vertical—such as is always, by necessity, on the letter *f.* This may more easily by referred to as a "head" and the corresponding leftward projector on letters such as *p* and *g,* a "tail." This feature must be seen as more decorative than practical, as it actually takes slightly longer to form a letter in this way than with a serifed ascender. Some writers, of course, freely mixed both types of endings to the letters in their Italic, as is often the case today.

As Italic continued to develop and spread in popularity throughout the fifteenth century, something very exciting was happening that was to affect not only the future of calligraphy but the course of the entire world. While the Chinese had moveable wooden type much earlier, and the Koreans had a system of moveable *metal* type by the early 1400s, Johannes Gutenberg, in about the year 1450, was the first to solve the mechanical problems presented by printing in Europe. Books could now be printed in days that would have taken months to write out by hand. His system of moveable type was rapidly imitated by others, and within thirty-five years, almost all the countries of Europe had their own presses.

By 1465, Italy was in possession of printing technology. The types designed for use in the early books were in direct imitation of the best hand-lettering styles of the day, which were, of

THE DEVELOPMENT OF ITALIC
1400 TO THE PRESENT

Humanist; early 1400's-late 16th century

The humanists of the early 1400's began copying out manuscripts in a clear, round hand based on ninth century Carolingian models.

Humanist Cursive, Serifed; 1420's-early 1500's

When written more quickly, the Humanist letters became slanted, and joined together.

Humanist Cursive, Non-Serifed; 1420s-early 1500's

Niccolo Niccoli's cursive Humanist hand sometimes had "heads and tails" at the ends of letters.

Griffo's First Italic Type; 1500

For Aldus Manutius, Griffo designed the first Italic type, closely based on the above version of Italic.

Cancelleresca Corsiva; 1520's

Italic written with heads and tails fully matured by this time, became more refined, and employed *fewer* joins.

Griffo's Second Italic Type; 1501

Griffo cut a second Italic type, greatly reducing the number of letters that joined with each other.

Types with Heads and Tails; 1520's

Following Griffo, many others, including Arrighi, designed Italic types, some with heads and tails.

Cancelleresca Formata; most evident 1515-1560

A slow, unjoined Italic with serifed, shortened ascenders and descenders, based on the above type, came into use.

Unjoined Cancelleresa Corsiva; 1530's-1550's

While fast, joined Italic was still in use, *unjoined* Italic with heads and tails also became more common.

Cresci; 1560

G.F. Cresci published a writing manual in 1560, emphasizing a faster version of the Corsiva, adding loops and using a thinner pen. The downfall of the true Italic began.

Scalzini; 1581

Influenced by the new copperplate engraving process, Scalzini encouraged an even faster version of Cresci's style, joining together *all* letters and using loops consistently.

Copperplate; late 1500's-1800's

Eventually all writing manuals were engraved onto copperplates. A pointed rather than edged pen was used, which used pressure to create contrast of line quality.

Palmer method; 1850's-present

The Palmer Method, a version of Copperplate *eliminating* any contrast of line quality, took hold. Almost all modern script taught to children today is directly related to such methods.

course, the Humanist letters in Italy. These letters eventually became known as lower-case roman (lower-case referring to the lower tray in which the printer kept the type, as opposed to the higher tray used for capitals). Countless variations have been made on these basic forms, and they have remained the most widely used of all Western printing types. The letters that you are reading on this very page derive directly from those early Italian printing types.

In the dawn of the sixteenth century, however, which was truly to be the golden age of Italic, the next developmental stage of the Italic style began, and was closely linked to the printing press. In the year 1500, an Italian printer, Aldus Manutius, commissioned the first Italic printing type. Designed by Francesco Griffo, it was very clearly based on the prevalent Italic handwriting, characterized by its slanting oval shapes. This type had serifed letters, and Griffo even created joins between the typecast letters, in imitation of the handwritten forms.

It was Griffo's second Italic type, however, designed a year later for another printer, that was to have a decisive effect on the future of Italic handwriting. While the first Italic type imitated handwriting, the second type began to be imitated *by* calligraphers, to some extent. For in the second version of Italic type, Griffo eliminated many of the joins between letters, giving a more refined feeling to the lettering as a whole. There is no evidence to be found of any Italic writing *without* joined-together letters before this time period. Yet soon after the nearly unjoined type became widespread, examples of Italic writing with few joins began to appear as well. Samples of an unjoined, slowly written version of Italic that made use of serifed ascenders and descenders can be found dating from about 1515. The ascenders and descenders were sometimes shortened as well, in keeping with those on Griffo's type. This version of Italic was later referred to as "Cancelleresca Formata," and sometimes, but again not always, a tendency to make the letters slightly wider and rounder in the "Formata" is apparent. Faster, informal versions of serifed Italic with joined letters were still in use as well. The second version of Italic, that made use of heads and tails, was also affected by the growing use of Italic printing types that employed few joins. While for the most part this version of Italic retained the use of joined letters, it did become more and more refined and formal-looking as time went on, due in part to the natural maturation of a style now nearly one hundred years old, but also to the need to compete with the regular, even and consistent look of Italic type.

The advent of the printing press was in many respects an unfortunate event for those who made their livings as calligraphers, for much of their copying work could now be done more efficiently by the press. One positive result, however, was that with the much wider availability of books, more and more people needed instruction in the arts of reading and writing. Many scribes, then, turned to the teaching of writing to earn a living, and in the sixteenth century, a great flood of instructional manuals on the art of writing began to pour forth.

The Italic style almost always took pride of place in these manuals, and it was usually a version with joins and heads and tails that was emphasized, and given the name "Cancelleresca Corsiva." The first of the writing books to give instruction for writing the Chancery hand was published in Venice in 1514. Sigismondo Fanti's *Theorica et Practica* gave extremely clear and detailed directions for writing Italics, to a greater degree than any of the later books on the subject. Unfortunately, however, due to the difficulty of reproducing models of small Italic letters, no actual models of the letters were shown alongside his instructions for Italic, although three other lettering styles were presented in the book, and did have accompanying models, in a very large size. How amazed the Renaissance scribes would have been to be able to obtain perfect and instantaneous reproductions of their work, as anyone can today on a copy machine! For them, however, the problem of reproducing calligraphy was a difficult one. Although it was an extremely time-consuming and delicate procedure, the only possible way to reproduce hand-

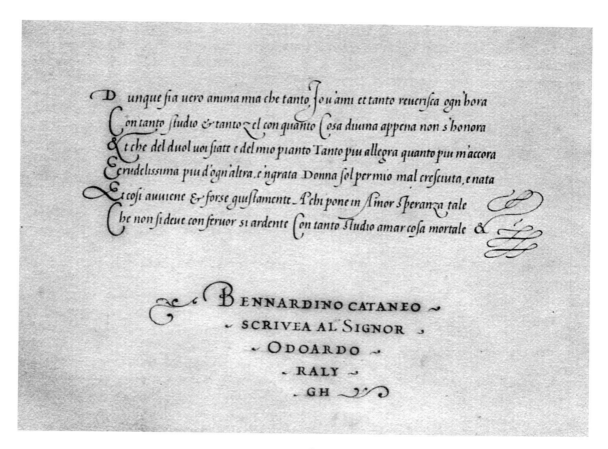

1. The Cataneo Manuscript. Bennardino Cataneo. 1545

written letters was to carve them into wooden blocks, from which they could then be printed. The Chinese had used this wood engraving process for centuries, and the Germans began to use it also, to produce illustrated books with minimal amounts of text some years before the perfection of moveable type. The Italians, then, again built upon German experience in printing. The very small, slanted Italic letters, however, proved especially difficult, because in order to have letters appear to be facing the right way when printed, they must be written onto the blocks in reverse. This problem was most likely surmounted by borrowing the Chinese method of writing the original copy onto very thin paper, turning it over, pasting it onto the block in reverse, and then cutting around the letters which showed through the paper, leaving each letter standing in relief.

The first writing manual to be produced in this way is often claimed to be that of Arrighi, published in 1522. Several scholars, however, have come up with some evidence that Arrighi's manual may not actually have appeared until 1524, the same year that a rival calligrapher, Tagliente, brought out his manual. Arrighi's manual, however, *can* claim to be the first one that was entirely written in Italic handwriting, unlike Tagliente's. The woodcarver, however, cannot really do justice to the quality of the original calligraphy, something Arrighi himself acknowledged, by adding a disclaimer in his book to the effect that the press could not really represent the living hand. A page from Arrighi's manual is reproduced in the title page of the fourth chapter of this book, and in comparing this to the photographic reproduction of Cataneo, *Figure 1*, the difference is readily apparent.

Once the Arrighi and Tagliente manuals were in circulation, many others on the subject began to appear as well, some of which were, of course, far more noteworthy than others. In addition to Arrighi and Tagliente, the third most popular author of an Italian writing manual was Giovambattista Palatino. Pages taken from his manual appear as headings for the second, third, sixth and seventh chapters of this book.

Perhaps as a result of the proliferation of these instructional manuals, the Italic hand began to spread to other countries. It was the hand taught at the royal courts, and became the mark of educated men and women throughout Europe. Other countries were soon producing their own writing manuals. Spain, Germany, Holland, England, France, etc., all adopted the Italic style to some extent. Each country, and indeed each author of a manual, showed a somewhat different version of the style, as might naturally be expected.

History demonstrates that almost all styles of writing go through a process of growth and development, gradually becoming more refined and formal in appearance, and then begin a slow decline as other styles take precedence. The Italic style of calligraphy seems to have reached its highest state of development, then, in the time period encompassing the early to mid-sixteenth century. By the 1550s, its use was widespread in all its forms; fast, slow, joined, unjoined, serifed, non-serifed, handwritten and typeset. Many others had imitated Griffo's types, creating numerous variations on them, some making use of heads and tails rather than serifs. Handwritten Italic continued to be influenced by type, and unjoined Italic with heads and tails became more commonly used as well.

The writing of Bennardino Cataneo (*Figure 1*) is a superb example of the grace, beauty and elegance that formal Italic with very few joins reached at its highest state. This sample, written in 1545, is taken from an original manual that was never reproduced in its own time period, but was meant for the private instruction of its owner, Edward Raleigh, who commissioned it. Though not apparent in this photograph, most of the capitals and flourishes are done in gold ink. If Cataneo and his peers brought the Italic style to its final state of perfection, then, perhaps it was almost inevitable that it complete its life cycle and that a new style be ushered in.

In 1560, a calligrapher by the name of G.F. Cresci published a writing manual that criticized the current Italic style. He complained that it was too slow to write, and that the letters were too narrow and pointed, and not slanted enough. As well, he felt that a narrower pen should be used. His style, as shown in his manual and in the chart here, began to lead to alterations of, rather than variations on, the Italic style.

It was also at this time that another change was taking place that was to have perhaps an even greater influence on the development of writing. Italian printers began to experiment with engraving onto copper plates, a process that would be much simpler than wood engraving, and could produce more accurate results. This process, once again, was taken from the Germans, who had already used it to produce illustrations.

It was soon found that the pointed engraving tool, called a burin, did indeed make the process of producing writing manuals much easier, yet it was more suited to creating letterforms other than those easily made with the edged pen. The pointed tool created contrast of line quality not as a natural result of the pen angle, but as a result of increasing pressure on certain parts of the letters to create thicker lines.

The first writing manual to be produced using this method rather than woodblocks was published by Hercolani in 1571. After that, virtually all manuals followed suit, with rare exceptions. The influence of the engraving tool was rapidly apparent. In 1581, a Venetian scribe, Scalzini, issued a manual attacking the Italic of Cresci, claiming it was still written too slowly and with too wide a pen. Scalzini's Italic, as shown in the chart in this chapter, began to show a radical

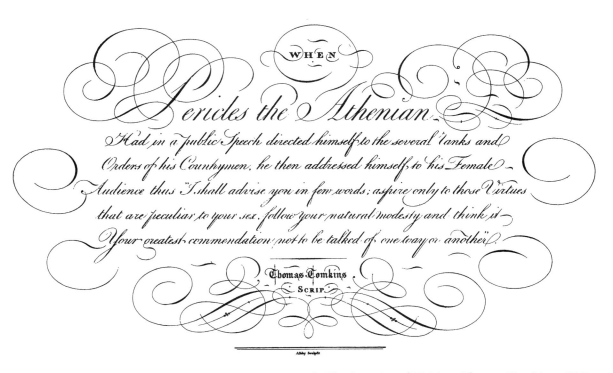

2. The Beauties of Writing. Thomas Tomkins. 1777

departure from the basic Italic forms that had now been in use for over 150 years. His script, a perfect example of the capabilities of the burin rather than the pen, was generally thin, with thickness appearing now mostly in the heads of the ascenders rather than throughout the letter bodies. He was very fond of creating loops, as was Cresci before him. Undoubtedly, his script really was a bit faster to write than the old Italic, in part because he allowed joins between *all* the letters within a word, whereas in previous versions of joined Italic many, but not all, letters had been allowed to run into each other.

Although the engraver's burin was partly responsible for these changes in the letterforms, the pen was made to follow along. Scalzini's advice was taken, and writers began cutting their quills to a point rather than an edge. Loops began to become a regular feature of the writing that had once been Italic, and the simple forms began to disappear into the new, highly flourished style, which today we generally refer to as "Copperplate," an example of which is shown in *Figure 2*, as well as in the chart. As the original Italic began in Italy and then spread to other countries, so developed the Copperplate style. Although some countries, especially Spain, continued with a modified form of Italic, written with an edged pen, as well as the new forms, one variation or another of Copperplate dominated the handwriting styles of all of Europe and America by the mid-seventeenth century. Excessive use of loops and flourishes, joining of all letters, a great degree of slant, and the use of a pointed pen that created variation of line quality through the use of pressure characterized almost all variations on the Copperplate style. Throughout the seventeenth, eighteenth and early nineteenth centuries, no dramatic changes took place in these basic characteristics.

About the mid-nineteenth century, however, as more and more children were sent to school, and as businesses had greater need of proficient clerks, new methods of teaching writing sprang up, based on the prevalent style, but with an eye only towards speed rather than beauty. It was

19

The thin gold shaving of the moon floating slowly downwards had lost itself on the darkened surface of the waters, and the eternity beyond the sky seemed to come down nearer to the earth, with the augmented glitter of the stars, with the more profound sombreness

3. A Handwriting Manual. Alfred Fairbank. 1932

faster, of course, to dispense with the varying of line quality in the letters, and to simply write with a constant and unchanging amount of pressure on the pen, which created letters of completely even line quality, exactly like a modern ball-point pen or pencil. The Palmer method, among others, in America, took hold, based on this principle, and if you look at the example of this on the chart, you will see that it is really the same style of cursive writing that most of us have been taught as schoolchildren throughout this century, the results of which are rarely pleasing.

The lack of both legibility and beauty that occurs when this style is written quickly with a monoline tool was the source of dissatisfaction by the 1870s in Britain, when the modern calligraphic revival really began to take shape.

William Morris, founder of the British Arts and Crafts Movement, took a great interest in reviving the arts of fine printing, book publishing and along with it, calligraphy. The owner of four Renaissance writing manuals, he took up writing with a broad-edged pen, creating illuminated manuscripts with a distinct Renaissance feel. It was he who paved the way towards having calligraphy again be considered a serious form of art. The first book to teach a modern, edged-pen version of Italic was published in 1898 by Monica Bridges, also in England. Several years later, Edward Johnston published his classic book, *Writing, Illuminating and Lettering*, which was concerned mostly with earlier calligraphic styles but also gave a version of Italic which was somewhat influenced by but not really based on typical Renaissance Italic.

Another Englishman, Alfred Fairbank, who was a student of Graily Hewitt, one of Johnston's early students, did intensive research into fifteenth and sixteenth-century Italic. He has done more than any other individual to revive the true Italic style and promote its use in this century, as both a formal calligraphic hand and a hand perfectly suited to everyday, informal usage by all. In 1932 he published his classic book, *A Handwriting Manual*, teaching a simple Italic style, and later published several other books on the history of writing. *Figure 3* shows an example of Fairbank's writing.

The Italic revival grows ever stronger, as it recognized by more and more people that the simple Italic forms, without loops, and written with an edged rather than pointed pen, are far more legible and beautiful than the Copperplate forms they degenerated into several centuries ago. Written slowly or quickly, for all purposes, Italic is the one style of writing that can truly allow handwriting to be "everyman's craft," as it should be. Schools are slowly becoming aware of this, and are changing over to Italic handwriting systems. It is hoped that this trend will continue until we come full circle, from the Copperplate-derived scripts back to the true Italic.

II
Tools & Materials

PENS

The edged pen, consisting of a pen holder and a "nib," which is usually detachable, is the basic calligraphic tool. There are three major types of edged pens commonly available: dip pens, fountain pens and marker pens.

Dip pens, which are frequently dipped into ink while writing, are the preferred tool, due to the wide range of nib sizes available as well as the finer line quality that can be obtained as a result of their thin metal. Three major brands of dip pen are Speedball, William Mitchell and Brause. Speedball (*Figure 1*) nib sizes C-0, C-1, and C-2 all work well, though the smaller sizes of Speedball are not of as good quality. William Mitchell Round-Hand, or Square-Cut nibs (*Figure 2*) are those most recommended. These may be purchased in sets of ten different-sized nibs along with a holder, and are sometimes available individually. Mitchell also puts out a set of nibs termed "Italic." These are numbered differently and come in sizes too small to use along with the letter models in this book. In any case, any edged pen may be used for a myriad of calligraphic styles, so terming a particular nib "Italic" can be misleading. Mitchell nibs may be used with a small metal plate, called a reservoir, that fits onto the back of the nib, to help control the ink flow (*Figure 3*). Brause nibs (*Figure 4*) come in nine different sizes and are much stiffer and less flexible than Mitchell nibs, a characteristic preferred by some and disliked by others. Nibs cut at an oblique angle are designed for left-handers, although the regular nibs may be used by left-handers as well, with equal success.

Several different types of pen holders for dip pens are usually available in art stores, and those that are slightly more expensive are worth it, because they are usually much easier to fit nibs into without forcing them.

Fountain pens, the second major type of edged pens, are easier to use at first than dip pens. The ink is contained inside the pen barrel, and therefore presents fewer problems in controlling ink flow. Osmiroid (*Figure 5*) is the best brand of fountain pen, and makes a great variety of different nib types and sizes. As of now, Osmiroid makes the only fountain pen nib large enough to use with the letter models in this book, the B-6 nib. Other brands of fountain pens are more limited in both quality and selection of nib sizes.

A third type of edged pen is the chisel-edged marker (*Figure 6*), now available in a great variety of sizes and colors from various manufacturers. While these tools are fun to use later on for

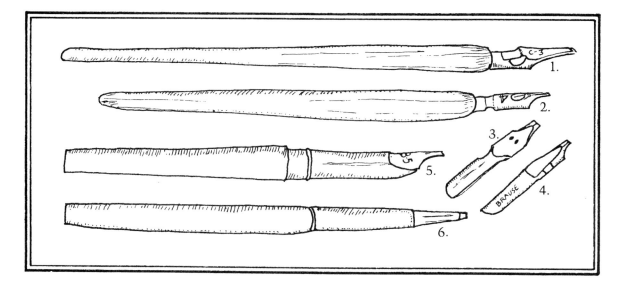

fast, informal work, they wear down and fade quickly, and are not recommended for learning or for any fine-quality work.

Reeds, quills and lettering brushes are tools that the advanced student may wish to experiment with, but using a modern metal-edged pen is much more advisable for the beginner.

INK

There are two basic categories of ink: waterproof and non-waterproof. The difference is that most of the time, waterproof inks are somewhat thicker than non-waterproof inks, due to the addition of resin to the ink solution. Non-waterproof inks should be used with fountain pens. The thicker ink could otherwise clog and destroy the pen's interior. Dip pens can be used with either waterproof or non-waterproof inks, and in general, waterproof ink is better. Some inks, however, are really too thick for any calligraphic use. Inks labeled "india" are usually especially thick waterproof inks that do not flow freely enough for writing. It is important to experiment, however, because each brand of ink is slightly different, and ultimately, it is really a matter of personal preference.

Higgins Eternal Ink, Engrossing or Calligraphy Ink are all good basic black inks for use with dip pens. Higgins makes some inks suited to fountain pens as well. Pelikan is another brand of black ink worth trying, as is Waterman's or Stephen's. The very best type of ink is Chinese stick ink, which is diluted with water and rubbed down on an ink stone to the desired consistency. This is a slow process, however, and although worth it, is still not often used by most Western calligraphers.

You will probably want to experiment with colored inks before long. Osmiroid makes colored inks for fountain pens, and Winsor & Newton, as well as Pelikan, make colored inks that can be used with dip pens. Dr. Martins is a brand of concentrated liquid watercolor that comes in a great variety of colors. All colored inks, however, present problems with transparency and permanence, and therefore some calligraphers prefer to use watercolor paints instead. In this case, tubes of watercolors, such as Winsor & Newton, may be used. The paint, mixed with water, is applied to the pen with a brush. This can produce more satisfactory results, although it is also a slower process.

PAPER

As with pens and ink, a great variety of papers is available. It is recommended that you use tracing paper when working with the letter-model pages of this book, in order to be able to see the models, guidelines and instructions as clearly as possible. You may then wish to go on to use plain white bond paper for practice. Packages of 500 sheets of Hammermill or other bond papers are usually available from stationery supply stores or copy centers, and are very inexpensive and excellent for practice.

Work that is going to be printed or photo-copied should be done on a somewhat heavier paper, such as ledger bond, bristol board or illustration board.

For finished original pieces, look for paper with a high rag content. Avoid glossy paper—the ink will sit on top of it and never thoroughly dry. On the other hand, paper that is too heavily textured can be difficult to work on also, and can cause the pen to catch and splutter. Some papers are simply too porous and ink will bleed right into them. For invitations, greeting cards, etc., you might want to try Crane's or Strathmore writing papers. Both companies make fine selections of correspondence papers in many different sizes and colors. Strathmore puts out a pad of laid papers of various colors, labeled "calligraphy" paper, which is worthwhile. Probably the best

all-purpose paper suitable for calligraphy, one that should be readily available in art-supply stores, is Canson "Mi-Teintes" paper. This comes in a great variety of colors, in large sheets that may easily be cut to the size desired.

Handmade papers may be the ideal, but are both expensive and hard to find, as are real parchment (sheepskin) and vellum (calfskin). You may see packages of paper labeled "calligraphy parchment," but these imitation parchment papers have no resemblance whatever to real parchment, and are usually not particularly good surfaces to write on. They are best avoided.

ADDITIONAL TOOLS

Some additional tools that you may want to have once you become more involved in calligraphy are as follows: 1. A T-square, essential for ruling straight lines. 2. Triangles, for ruling vertical or angled lines. 3. Soft erasers, either plastic or kneaded, for erasing ink and pencil lines. 4. A dust-brush, for removing eraser crumbs. 5. A metal ruler, for measuring and cutting against. 6. An x-acto knife, for cutting paper. 7. Rubber cement, for pasting up work for reproduction. 8. A rubber cement pick-up, for removing dried excess rubber cement. 9. An electric eraser, useful in removing ink from some papers. 10. A light table, useful for large projects such as envelope addressing, in order to be able to see guidelines through the paper. 11. A drawing board. While it is possible to work on a flat surface, it is really much better to work on a slanted surface. 12. A floating arm lamp, which can adjust to the proper position over your drawing board or table. 13. An assortment of pens, pencils, markers, etc.

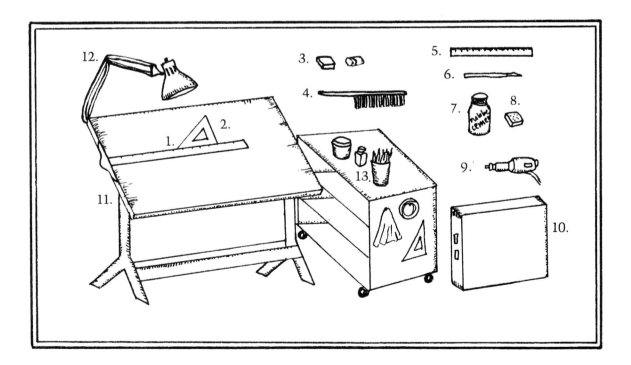

III

Fundamentals

La . g . et la . z . Anchorche' non si usino .
tutta uia se ne' fanno in questo modo.
ʀ a g g g . ꝛ ꝛ ꝛ ꝛ ꝛ ꝛ .b℮.

Regole' Generali .

Tutte le' haste' hanno da essere' alte' doi
corpi de la lettera & deueno essere' eauali
così quelle' di sopra come' quelle'di sot ʒ
to come' uedete' .

bb dd ll mn ss pp qq ʒ

Le' lettere' che' si fanno in un sol Tracto o
uolemo dire in una tirata di penna son
queste', a b c g h ik l mn o g r s s u z & g.
Tutte' queste' altre' che' sieguono si fanno

DEFINING CALLIGRAPHY

When learning any art or craft, it helps to begin with a clear idea of one's aims.

The aim here, of course, is to learn calligraphy, which—literally translated from the Greek—means beautiful writing. But what exactly does writing mean, and is there an acceptable definition of beauty?

Writing, in a broad sense, simply means making marks on a surface, with the intention of communicating ideas or information. This basic function, communication, can only be served when the writing can be read easily and clearly. The first goal of any type of writing, then, should be legibility. The ideal, basic forms of the Italic letters are really the most legible forms of those letters. Letters that are too narrow, too wide, too fat or too thin are harder to look at and distinguish easily. Aim, then, for legibility first, which comes from perfectly balanced, well-proportioned, simple letterforms. A balance must also be created between the words and the white page-space, in the form of adequate space, between and surrounding lines of writing, for maximum legibility.

Beyond legibility is beauty, the second goal of calligraphy. While beauty may ultimately be subjective, there are certain definite qualities that do contribute to what is generally considered beauty in writing. To begin with, a basic sense of balance, within each letter and the composition on the whole, must be present. A sense of unity and consistency comes next, and while this may be the hardest goal of all to achieve, it must be sought after. Qualities of strength, energy, grace, flow, movement, life, personality and freedom also contribute to beauty, and these can only come after much disciplined practice.

DISCIPLINED FREEDOM

The essence of calligraphy really is disciplined freedom, and discipline comes first. Conscious, aware practice is essential in the beginning. Good, simple models must be followed, preferably with a large pen, so that all details of letter construction are readily apparent. An attempt must be made to imitate the letter models as closely as possible at first, so that you can really begin "seeing" letterforms. There is, in all of us, a resistance to truly *seeing* the basic forms at first. Then comes a resistance in your hand to creating on paper what your mind's eye does see. It is a matter of breaking through this natural resistance, first in seeing, then in controlling the hand. The hand must be trained to move in certain patterns, much as fingers do on a piano. *Only* by repetition can these patterns become ingrained and letterforms occur naturally and easily.

While not claiming that it is easy to learn, this book tries to make it as clear and simple as possible for you to grasp the fundamentals. By gaining a full understanding of letter construction to start with, you will build a solid base from which to jump eventually from discipline into disciplined freedom. Once you can write the basic forms with ease and confidence, you may experiment with variations. Your personal style, however, should not come from an inability to create forms similar to the models, but from a conscious decision to alter them. True freedom results from true understanding. You must know exactly what you are freeing yourself *from*.

ESSENTIAL CHARACTERISTICS OF ITALIC

In learning any new calligraphic style, two fundamental questions must be asked. First, what exactly are the essential characteristics of the style? The basic underlying shapes of the letters, their right proportions, their uprightness or slant will be included in the answer to this. Secondly, just how are the letters created? The type of pen used, the angle at which it is held, the type of pen strokes made and their correct sequence must be considered in the answer to this.

1. Skeletal Forms of Letters

abcdefghijklmnopqrstuvwxyz

2. Basic Elements of Letters

/ ‾ ı l ı) ı / un

3. Family Likeness Groups

ilt aqgd uy hbpjkrnm
sf x z coe vw

4. Anatomy and Proportion

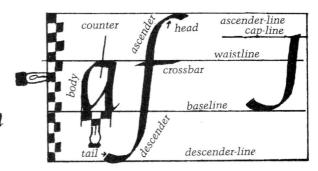

These basic points, in relation to the Italic style, are addressed thoroughly in this chapter.

To begin, every alphabet has what is called its "skeletal" form, as shown in *Figure 1*. The underlying structure, or basic shapes, can be seen in this way. In the Italic style, these fundamental shapes are slanted ovals and rectangles. As noted in Chapter One, Italics began its development in early fifteenth-century Italy, when Humanist scholars began writing a faster version of the rounded Carolingian style of writing that they had recently revived. When the hand moves more quickly, rounded shapes tend to become ovals, and shapes closer to squares become rectangles. As well, letters often begin leaning in the direction of writing, creating slanted rather than upright forms. As the Italic style developed further, reaching its full maturity by the mid-sixteenth century in Italy, much slower, more carefully formed versions of the basic style were written, yet even when speed was not a factor, the basic slanted oval shapes of the letters were retained, having become the essential characteristic of the style. The degree of slant is normally anywhere from 5 to 10 degrees to the right, and ultimately, this is a matter of personal sensibility.

The basic Italic letters are made up of certain elements, which are shown in *Figure 2*, done with an edged pen. Every calligraphic alphabet is like a large family. A resemblance is apparent in all the letters, but some will resemble each other more than others. *Figure 3* shows groups of letters that are all constructed of similar elements, often referred to as family-likeness groups. You will be learning the letters in their groups, rather than in alphabetical order. This gives you a much better sense of how the letters relate to each other, and greatly helps in working towards consistency, that difficult-to-attain but important goal.

Legible and beautiful letters are well-balanced, well-proportioned designs, complete in themselves. Proportions, or proper height and width of Italic letters, can easily be figured out with an edged pen. If you were to take your pen and hold it parallel to a straight line, make a square and then stack four more squares on top, you would have the ideal height for the bodies of your letters, five times the width of your nib. Certain letters have ascenders or descenders, parts that extend above or below the bodies, and these are also five pen-widths high, as shown in *Figure 4*. Capital letters, so as not to overpower the small letters, are seven-and-one-half pen-widths high. For maximum legibility, a three-to-five width/height ratio seems to work best. This gives the inside shape of the letter, commonly called the "counter," a width of two or two-and-a-half pen widths. It is important to look at these white spaces within and surrounding your letters right from the start. They are just as much a part of the overall design you are creating as the black lines you've left on the page.

BALANCE

The definition of *proportion* is as follows: "A harmonious relationship between parts or things: balance or symmetry." "The harmonious proportions of elements in a design" is one definition given for *balance* in Webster's dictionary. Balance can also be defined as follows: 1. To be equal in value or weight. 2. To have stability. 3. To be centered. 4. To regulate so as to keep in a state of just proportion.

Proportion, then, is really almost identical to balance. The principle of balance as being basic in calligraphy is sometimes overlooked by Western calligraphers, although Chinese calligraphers have been very much aware of it. The Chinese create their characters to achieve perfect balance within a nine-fold square.

Roman capitals, the most noble of our Western letterforms, also balance perfectly within a square.

The Italic alphabet is a superb example of an alphabet that contains perfect balance within itself as a whole, as well as in each individual letter, though not based on a square.

Balance occurs here when:

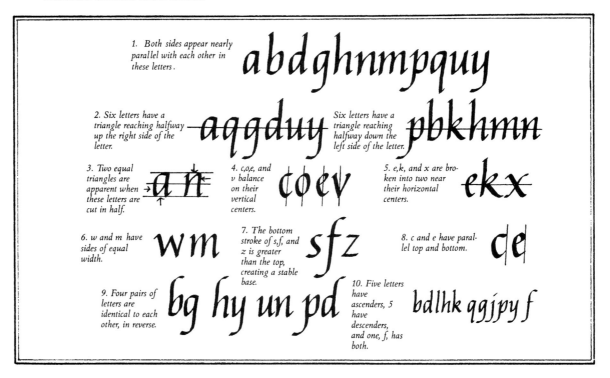

1. Both sides appear nearly parallel with each other in these letters.

2. Six letters have a triangle reaching halfway up the right side of the letter.

Six letters have a triangle reaching halfway down the left side of the letter.

3. Two equal triangles are apparent when these letters are cut in half.

4. c,o,e, and v balance on their vertical centers.

5. e,k, and x are broken into two near their horizontal centers.

6. w and m have sides of equal width.

7. The bottom stroke of s,f, and z is greater than the top, creating a stable base.

8. c and e have parallel top and bottom.

9. Four pairs of letters are identical to each other, in reverse.

10. Five letters have ascenders, 5 have descenders, and one, f, has both.

Letters should be imagined as pieces of gold sculpture. Do they stand firmly on their bases with no danger of tipping over, or do they look lopsided and about to topple over from unbalanced weight? Once you have begun creating the letters yourself, keep this analogy in mind, and refer back to the balance chart every once in awhile.

STROKE SEQUENCE

A sense of fluidity and life is the essence of Italic—when it is written slowly just as much as when it is written quickly. Forming nineteen of the twenty-six small Italic letters (*minuscules*) in one continuous stroke, without lifting the pen, is of great importance in achieving this living,

One-Stroke Letters

a b c g h i j k l m
n q r s u v w y z

Two-Stroke Letters

p o e t d f x

flowing quality, as was emphasized in the Renaissance writing manuals.

Early in the twentieth century, however, a technique of forming most Italic letters in several strokes instead of one was first advocated by Edward Johnston, and has been adopted by some other modern scribes as well. This technique stems from the idea that the pen should be "pulled" rather than "pushed." It is true that there is a very slight natural resistance to "pushing" the pen; yet this problem is *truly* slight compared to the much *greater* difficulty encountered in breaking letters into several parts and trying to join them up smoothly and gracefully.

The push/pull, up/down rhythmic motion is truly the life-force of the Italic alphabet. In any case, if absolutely *all* strokes are "pulled," a wholly different alphabet, much more Gothic than Italic in character, is the result.

USING THE PEN

Controlling the ink flow is one of the greatest challenges to the beginner using dip pens. First, it helps to wipe off new nibs with a rag, or better yet, to hold them under a flame for an instant, then immerse them immediately in water and wipe them off. Either way, the thin coating of protective film on the nibs will be removed. If you don't do anything, the nib will simply take a little more time to break itself in and be harder to use at first. Always keep your nibs clean. Even as you work, you will find that it helps to dip your nib into some water and wipe it off once in a while, to prevent possible ink build-up. Water and a rag or old toothbrush are all you need to clean off your nibs at the end of each practice session.

Fountain pens, Speedball and Brause nibs come with attached reservoirs, to help contain the ink and control the flow. Mitchell nibs can be used with a slip-on reservoir, as already shown in Chapter Two. Some people find them useful, others don't; you will have to experiment to see what works best for you.

In order to prevent excessive ink flow, always wipe off excess ink on the interior of the ink bottle after you have dipped the pen in. Try not to get discouraged if it seems hard to control at first—with practice, you will get used to it. Be sure to keep a cloth rag or paper towels handy as well. Ink will get on your fingers sometimes, but it does wash off easily with soap and water. Also, always keep a piece of scrap paper next to your work, and before ever writing anything, make some lines on the scrap paper to test the flow and rid the pen of excess ink.

It is important not to hold the pen too tightly, or press down too hard. A very light touch must be developed. You must also be absolutely sure that you are allowing the full edge of the pen to touch the paper. Problems often occur in the beginning when only part of the pen's edge actually comes into contact with the paper. If your letter has a ragged-looking edge, this is probably the reason.

Correct pen-holds are also important. Hold the pen between your thumb and first finger, and allow your other fingers to function merely as support. If you're used to holding regular pens or pencils a different way, do try to reform and use this pen-hold, as it really does work best.

Right-handers are best advised to keep the paper straight in front of them at first. Left-handers have two choices. One is to have the paper at an angle, as shown, and to crook the hand somewhat. The alternative is to keep the paper straight up and down and to hook the hand above. This, however, sometimes causes problems of smearing freshly written work. With this position, therefore, the left-hander may find fountain pens preferable, since the ink dries faster. Left-handers are certainly every bit as capable of learning calligraphy as right-handers, but just may have to experiment a bit more in the beginning to find out what works best for them in regard to pen-hold and paper slant.

Right-hander's position Left-hander's "hook" position Alternative left-hander's position

PEN ANGLE

Part of what creates beauty in Italic letters when made with an edged pen is the contrast between the thick and thin lines. Proper thicks and thins are best created when the edged pen is held at a 45° angle to the paper. Try moving your pen in different directions on the paper to get a sense of the different line weights that will occur. When moved diagonally along its edge at a 45° angle, the pen will produce its thinnest line. When moved horizontally across, a much heavier line will occur. It does feel unnatural at first, and takes time to become a habit, but it is of utmost importance that you continually check to see that your pen is held parallel to the 45° angle lines running across the letter model pages of this book at all times. Any time parts of your letters look *too* thick or *too* thin, as compared to the models, it is probably as a result of a change in the pen angle. Maintaining the 45° angle is truly the most important thing to work on when beginning to learn Italics. The only times when the pen angle *should* change, and alter to about 15°, are the crossbars of *t* and *f* and the second stroke of *e*.

The illustration below demonstrates pen angles that are correct, too flat, or too steep.

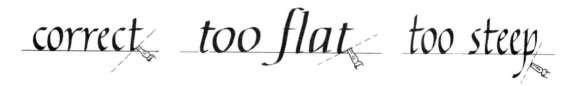

HOW TO USE THIS CHAPTER

Do not write directly onto the ruled pages of this book! Use tracing paper or thin white bond paper over them, so that the letter models, lines and instructions can show through and the pages can be used again and again.

Be sure to use the proportionally correct pen size along with the letter models in this chapter. Use either a Mitchell Round-Hand #1, a Speedball C-2, a Brause 3mm, or an Osmiroid fountain pen with a B-6 nib.

Your state of mind when doing calligraphy is of importance—if you are not in the mood for writing, you will probably be too resistant to allow the natural flow of the lines to occur, and the results will not be satisfactory. It may well be that "innate ability" in calligraphy or any other art form is not something that one has, but rather what one *lacks*—that is, a total *lack of resistance* to learning and to expressing oneself through the given tool and medium. The idea is to open yourself up fully—mind, eye, spirit and hand—to the experience of creating letterforms. Take a few minutes before practicing, close your eyes, and try to allow your mind to become clear of other thoughts. Allow the creative energy that is within you to rise to the surface. Then open your eyes, and really look at the letters. Study the models in detail. Know exactly what it is that

you want to achieve. Read the instructions surrounding each letter. Begin by tracing over the models at least a few times. Then try the letters without tracing, fitting them into the slanted rectangles. Don't worry about squeezing them into this space. It is all right if they are a bit wider, but not narrower, as these spaces represent the minimum width that the letters should be. These slanted rectangles are simply a guide to help train your eye to see the correct proportions and your hand to create rightly proportioned shapes. By using them at the beginning, you will be instilling in yourself this basic sense of proportion, which will stay with you later on, when you will write without such guidelines. The use of training wheels on a bicycle as an initial aid to help achieve balance is a perfect analogy—especially as the purpose in calligraphy is also to achieve balance, or right proportions.

Do as many of each letter as it takes for you to feel that you really have a good sense of the shape, and continually refer back to the models and trace them once in awhile. Don't be upset if you have done a page of letters and they all look slightly different. Consistency is a long time in coming, and *only* comes with practice. *Do* save your practice sheets! You will be glad to have done so later on, as it is the only way to measure your progress.

Letters are like stories; they have beginnings, middles, and endings, and each part deserves equal attention. If letters don't start off right, it is unlikely that they will end up right. On the *"a"* group of letters in particular, the beginning is very important—the horizontal stroke must be brought far enough over to the left before the downward curve is begun in order to avoid lopsided, unbalanced letters. The middle is also very significant. There is an invisible dynamic centerline running through almost all Italic letters, where curves begin, and branching in and out of the letter bodies occurs, creating the important triangular shapes. Refer back to the balance chart concerning this. The ends of the letters are equally important. The very short diagonal finishing strokes that are on many of the letters give them a sense of wholeness and completeness. Be sure to give the endings just as much attention as the rest of the letters.

Generally, when the eye detects a curve in a letter, when first practicing the shape, there is a tendency to exaggerate that curve. However, be aware that *subtle, gentle* curves are part of the beauty of Italic letters, which are based on an oval, and should not be too rounded or too harsh and angular.

Don't be discouraged if the lettershapes don't come as easily as you would like. Some are simpler than others, but many *are* quite difficult. The *"a"* group, as well as *p, k, o, e, c, s, f, v* and *w* are the hardest for most people. Just keep at it. The rewards can be tremendous, if you will just give it enough time. There is *no* substitute for practice. The more time you spend practicing, the better you will become, and the more satisfying and enjoyable it will become for you. Allow yourself to enjoy every step of the way, always appreciating where you are while at the same time aiming to reach a higher level of proficiency. Just keep aware of both your aims and the results you are producing at all times.

Everyone must find the speed and rhythm that works best for them. It is important not to go too quickly at first. Yet it *is* possible to go too slowly as well. If your hand seems shaky, and it is very difficult to make straight verticals, try speeding up just a bit.

At first your hand may seem to tire easily, but with more practice, your muscles will strengthen. Hold the pen *lightly,* without pressure, and always allow your whole hand, wrist, and arm to move as you write—never just your fingers, which would be cramped and uncomfortable. Continually check your 45° angle until you are sure that you really have it all the time.

Many people find that listening to their favorite music as they practice encourages a sense of rhythm in their writing. In any case, relax, take pen in hand, and enjoy your journey through the alphabet, that most wonderful invention of mankind.

32

ANALYSIS OF THE ITALIC LETTERS

The letter *i* is the simplest of the Italic letters. Begin by placing your pen at the 45° angle a bit under the waistline, move upwards and touch it, and then go straight down to the baseline. Finish with a very short upwards diagonal. Either a dot or a dash may be used on top of *i*.

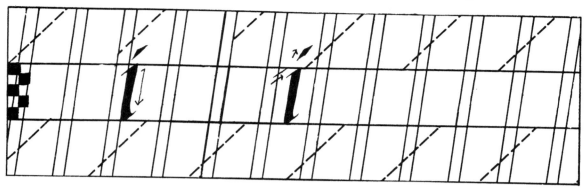

The letter *l* is made exactly like *i*, except, of course, that it is twice as high. Use the slant lines to align verticals such as *l* as you practice.

The letter *t* may be made several ways, and this is the simplest version of it. Begin about one-third of the way up into the ascender space, come down to the baseline, and up with the short diagonal as with *i* and *l*. The second stroke is the crossbar, and you may, if you wish, change your pen angle here, flattening it slightly, to produce a thinner line. Keep the crossbar quite short on the left side, and bring it farther to the right than to the left.

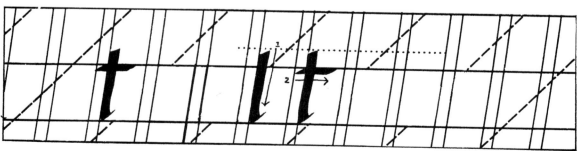

The underlying structure of the letter *a* is a rigid triangular shape, as shown here. Practice this shape several times, just to get a sense of it, pushing the pen to the left and then down to the baseline, and then up at a severe angle. Then make the same shape, adding gentle curves, and you will come closer to the real shape of the letter. It is very important to bring the first horizontal stroke at least two-thirds of the way over to the left before beginning the downwards curve. Then, once the curve is begun, bring the pen about halfway down the left vertical—at this point, begin to curve in very slightly to the right, so that when you reach the baseline, the pen is just slightly to the right of the slant line. Not very much of the letter should be actually sitting on the baseline. Almost immediately, aim towards the right-hand corner, joining the shape right where you began it. Do practice this shape alone before trying a full *a*. Then, when you are ready to go on to *a*, make the same shape but finish it off by bringing a vertical stroke down on the right side, ending it the same way as *i*, *l*, and *t*. Make sure that a triangular shape can be seen, reaching nearly halfway up the right side. If it can't be seen, then you have probably made the bottom of *a* too rounded.

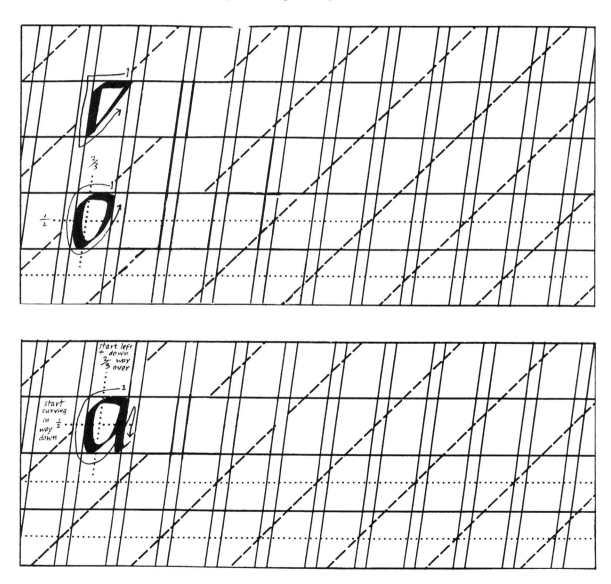

34

The letter *q* is exactly like *a* with a descender. The letter *g* also begins with the same shape. Its descender, however, is different from that of *q*. About two-thirds of the way down the descender space, begin curving to the left. Keep the tail fairly short, at first, and rather than having it lay absolutely flat, let it curve up very slightly, which gives it more of a sense of life.

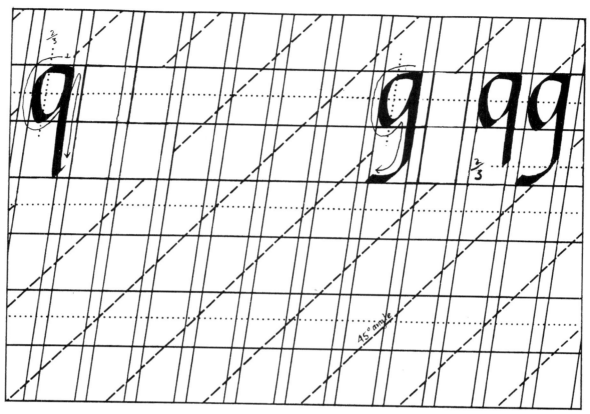

The letter *d* is a two-stroke letter. Begin with the same shape that starts *a*, *q* and *g*, but then lift the pen, and make an *l*, intersecting it right over the right-hand corner of the basic shape. It can be difficult, at first, to judge exactly where to place the *l* shape, but with practice, you will get it.

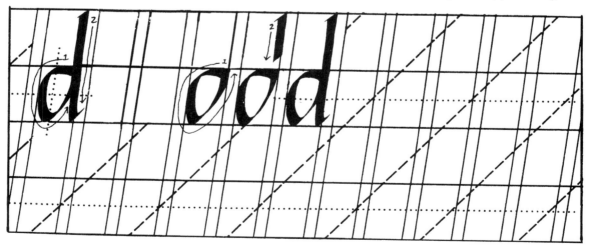

The letter *u* begins like *i*, but just as in the *a* shape, halfway down the left vertical, begin curving in slightly to the right. Again, be sure that the triangular shape is evident.

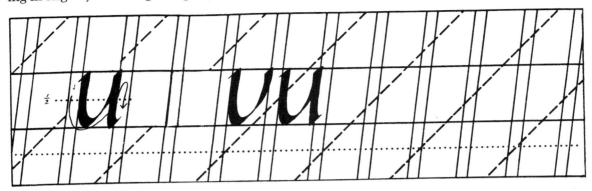

The version shown here of the letter *y* is formed exactly like *u* with a descender. The letter *j* is like the descender of *g* and *y*, and again, rather than letting the tail lay perfectly flat, instead allow it to curve upwards ever so slightly.

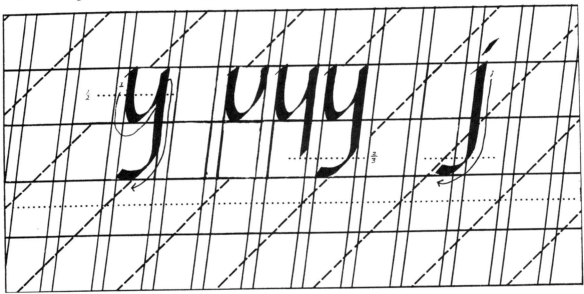

The letter *n* is just like *u* upside down. Begin as if you were making an *i*, but when you reach the baseline, travel halfway up the vertical, and then begin branching out to the right. Head for the right-hand corner, then come down the right side almost straight, and after touching the baseline, finish with the short upwards diagonal. This time the triangular shape should be evident in the upper left part of the letter.

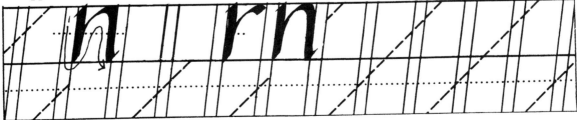

The letter *h* is just like *n* with an ascender. The letter *b* is the same as *h*, except that when you are about two-thirds of the way down the right side, begin curving in and very slightly upwards, joining into the long vertical stroke at the baseline. Upside down, *b* is the same as *q*.

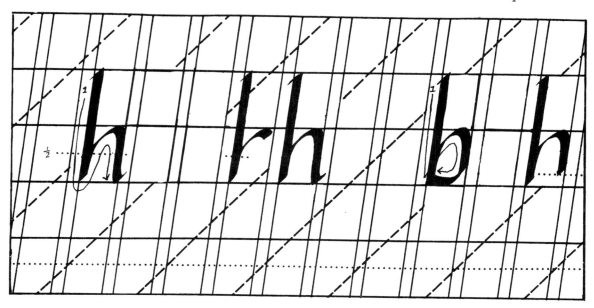

The letter *p* begins with a *j* shape. Then lift your pen, and place it on the vertical exactly at the baseline, never higher up! Just as in *h* and *b*, travel halfway up the vertical, and then branch out to the right. The two sides of all these letters should really look nearly parallel with each other, so be careful not to make the right side too curved or rounded.

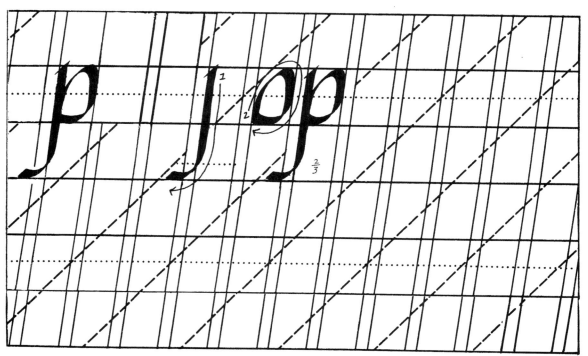

The letter *m* is exactly like two narrow *n*'s put together. Be careful not to let it get too narrow, however. So many straight lines in a row can looked cramped and uncomfortable if too close together.

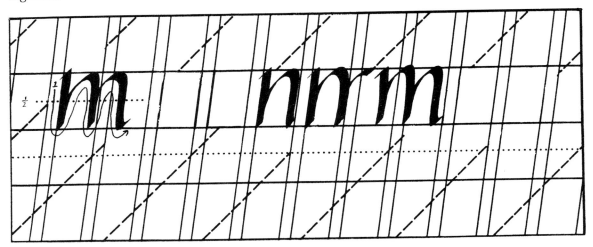

The letter *k* begins like *h* and *b*. Once you have branched out at the center and begun travelling down the right side, turn quickly and aim for the center again. Then make a straight diagonal line, aiming for the baseline, allowing a slight curve to occur *only* as you are close to the baseline.

The letter *r* is *not* exactly like the beginning of *n*. Instead of being halfway up when branching out begins, here it is best to be about two-thirds of the way up the vertical. Keep the rightwards stroke of *r* short and almost flat. Don't allow it to droop downwards or look like a hook.

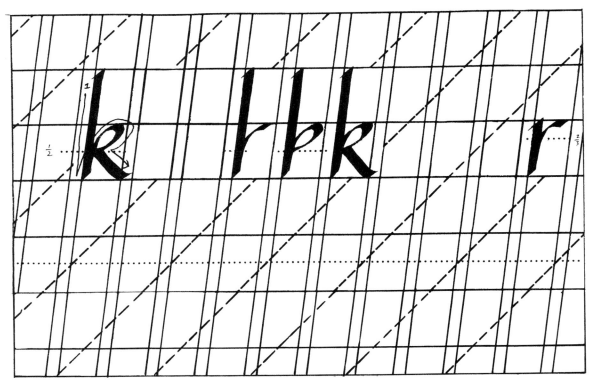

The letter *s* is very difficult, and needs much practice. Think of it as three straight strokes, connected by very slight curves. Most problems with *s* happen when the curves are exaggerated. The middle stroke really is almost a straight diagonal, and the bottom stroke should always be slightly wider than the top stroke. Don't let *s* be too wide; it is actually a bit narrower than the other letters.

The letter *f* begins with a short horizontal leftwards push-stroke, then goes into a long, flowing descender, ending up with a tail like *p*, *y* and *g*. It is essential to be very aware of maintaining the 45° pen angle all the way down on this long stroke. Then, ironically, it is important to *change* your pen angle, to flatten it to about 15° for the crossbar, as a heavy crossbar can destroy the graceful, flowing quality of *f*. Also, as with the crossbar on *t*, it looks much better if it is *not* centered, but extends farther to the right than to the left. Keep it slightly shorter than the head of *f* in most cases.

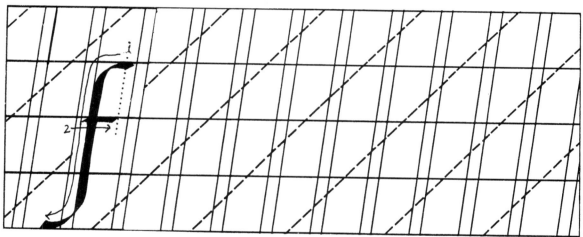

The letter *z*, like *s* and *f*, looks more balanced if the bottom stroke is just slightly wider than the top. You may also wish to change your pen angle slightly on the center of *z*, in order to achieve a thicker stroke.

The letter *x* is fairly simple, and does not need as much practice as some of the other letters. Cross it right at the center, and don't allow it to be too wide.

Begin *c* like *a*, with a horizontal leftwards push-stroke, going at least two-thirds of the way over before curving down. Halfway down the left vertical, begin curving downwards and to the right. Rather than curving just slightly, however, as in *a*, aim this time to hit the vertical center of the shape, allowing *c* to balance on the center. Don't ever let *c* be too rounded, or let too much sit on the baseline. *C* also looks best if the top and bottom are nearly parallel with each other.

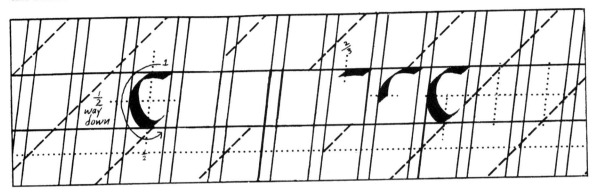

The key to the Italic alphabet is the *o*, as it establishes the basic slanted oval shape, and it is a very difficult letter. Start the first stroke a bit under the waistline, as shown, and just as in *c*, halfway down the left vertical, begin aiming to hit the vertical center on the baseline. Go back up to the top, for the second stroke, join where you began, and come around to the right, joining into the bottom right. It is, of course, possible to do *o* all in one stroke, but it usually does not look quite as good if done that way. All of the instructions concerning the letters in this book are based on what usually produces the best result for most people. The result is what counts, and if you find another way to make certain letters that still produces the same results, feel free to do it that way.

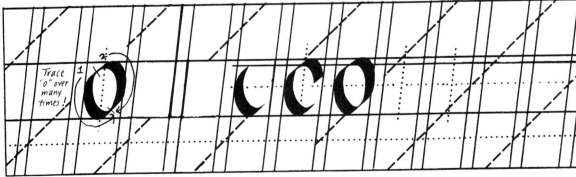

The letter *e* is also a difficult letter, and the first stroke is made just like the first stroke of *o*. The second stroke begins the same way as well, but on *e*, aim for the horizontal center or slightly above. Another exception to the 45° pen angle rule occurs here—in order to produce a thinner stroke going into the center, do flatten your pen angle.

40

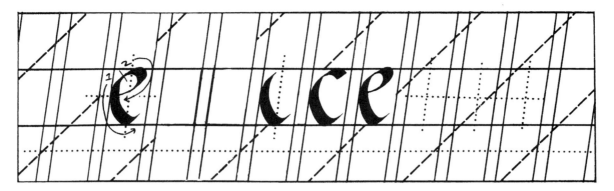

The letter *v* is similar to *c*, *o*, and *e*, in the sense that it balances on its vertical center. With the first stroke, aim for the vertical center, then come up, keeping it straight almost until you reach the waistline. Then curve in *very* slightly.

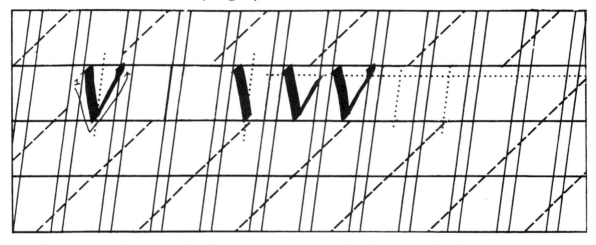

The letter *w* is like two slightly narrow *v*'s put together. Be sure to think of it as four straight strokes, with curves occuring *only* very near the top of the fourth vertical. Aim to have both sides of the letter equal with each other, as is also the case with *m*.

Numbers & Punctuation

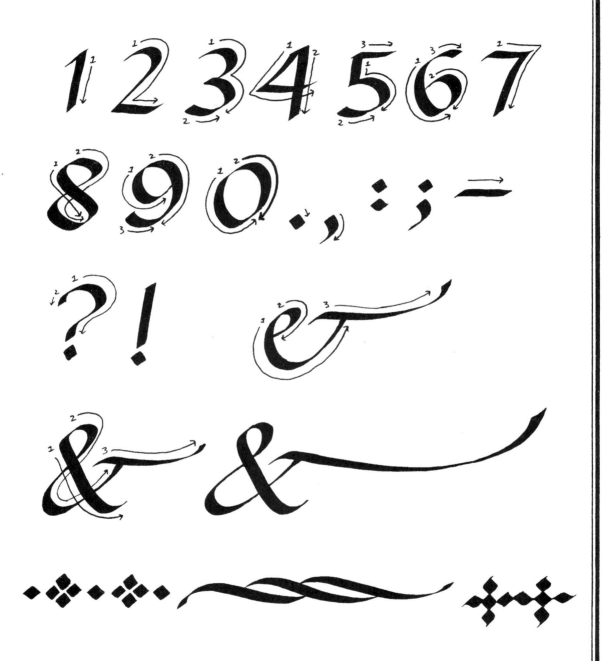

IV

Spacing

Farai che la
distantia
da linea a linea de' cose' che' tu
scriuerai in tal littera
Cancellaresca
non sia troppo larga, ne' troppo stretta, ma
mediocre
Et la distantia da parola á parola sia
quanto e' vno n: Da littera ad
littera poi nel ligarle' sia
quanto e' il biancho tra le' due' gambe
de lo n
Ma perche' seria quasi impossibile' serua=
re' questa regola, te' sforzarai di consigliar
ti con l'occhio, et a' quello satisfare', il
quale' ti' scusara bonissi
mo Compasso

A X

FOUR TYPES OF SPACING

There are four types of spacing to be considered here. The basic idea, again, is perfect balance. Each letter must appear perfectly balanced, or centered, between the letters before and after it. Each word will be balanced as well, between those before and after it. Lines of writing will achieve balance in their relation to one another, and finally, there must be a balance between the page area taken up by the text and the margin space. The effect desired is an even look to the page. The lettering should be what attracts the eye first. Empty white pockets of space, a result of leaving too much space, must never jump out from the paper. A cramped feeling comes from spacing that is too tight, and is equally unattractive. Legibility comes first. Aim to make it as easy and pleasant as possible for your work to be viewed.

Ultimately, your eye must be the judge. There are some basic principles that can be applied, however, and in the beginning it is wise to try and follow them. Below is a discussion of the various types of spacing.

Letterspacing. There are three possible combinations of letter shapes that need slightly different amounts of space between them. First, two curved shapes, such as two o's, need the least amount of space—at least one-half a pen-width. Next, a curve alongside a vertical, such as o and *l*, needs a bit more space, at least one pen-width. Third, two verticals, in order not to look too cramped together, need the most space, at least one-and-a-half pen-widths. Therefore, while there is actually some variation in the amount of space between letters, they should give the appearance of evenness to your eye, which must be the real judge.

Certain letters present particular problems in spacing. Generally, these include all the "open" letters, as opposed to those which totally enclose their counters, or interior space. Because of the open space to the sides or under the crossbars of the letters *c, e, f, k, r, s, t, v, w, x* and *z*, it's important to be aware of placing the adjacent letters a bit closer than you might think warranted at first.

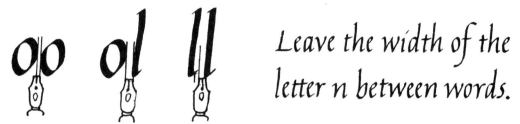

Wordspacing. If words are too far apart, your eye has to travel farther and work harder. If too close together, it is too difficult to distinguish words easily. Make it easy on the eyes. For the sake of maximum legibility, it works best to leave just about one letter-width between words, such as the letter *"n"* or any closed Italic letter. When a word ends with an "open" letter, such as *r, t, c*, etc., be especially careful not to leave too much space.

Linespacing. Normal Italic linespacing means writing on every third line, as marked on the guidesheets in this book, in order to allow room for ascenders and descenders. As with letter- and word-spacing, if lines are too close together, they can look uncomfortably cramped, and if too far apart, they can make your eye work harder in traveling from one line to the next. Therefore the best linespacing is generally the most legible. However, there are occasions when linespacing can be altered. Tighter linespacing is sometimes necessary in order to fit a certain

amount of words within a given space, and wider spacing is sometimes appropriate as well, especially when using flourished ascenders and descenders, as shown here. As evident, a different texture results on the page from tight, normal or wide linespacing. In the future, if you are using a T-square to rule lines directly onto your paper, you will have total freedom to place lines as you wish.

Normal italic linespacing – writing is on every third line so that ascenders and descenders don't touch.

Tight italic linespacing – if writing on every second line, both ascenders and descenders must be kept shorter than usual.

Extra linespacing allows room for flourishes...

Entire Text. There must be a balance between the amount of space your lettering takes up in relation to the margin space. The ideal may actually be 50/50. The idea is to allow the white margin space to act as a frame for the composition. On a single page layout, side margins should be equal, the top perhaps a bit less, and the bottom margins are usually greater than the top or sides. The bottom margin acts as a cushion that supports the weight of the entire composition. Be generous with it. The illustrations here show correct and incorrect amounts of margin space.

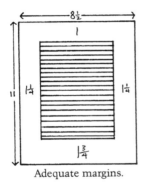
Adequate margins.

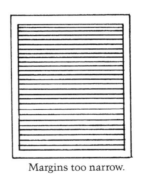
Margins too narrow.

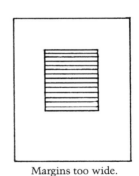
Margins too wide.

HOW TO USE THIS CHAPTER

Trace over the quotes on the left-hand pages in this chapter several times, using the correct pen size. Always check your pen against the five-pen-width height, to make sure you are using the proportionally correct size. Then try writing the quotes out on your own without tracing them, using tracing or bond paper over the corresponding guidesheet. You may wish to have the guidesheets photocopied, in order to have extra copies that can lie flat against your table. Be aware that slant lines are still used on the pages in this chapter, but they no longer have *any* relation at all to the letter *width*. They are much too widely spaced for that, and are meant only for you to check your verticals against, in order to gain a consistent slant to the lettering.

Remember your aims as you proceed. Legibility, then beauty. These are created by well-balanced letters, words and pages. Continue to work towards consistency of pen angle, slant and letter proportions, as well as spacing. A sense of life, flow, energy and personality will begin to emerge in your writing after a basic sense of balance and consistency is established.

Discipline comes before freedom ! Go slowly, with an awareness of your aims.

Use this guidesheet with a Mitchell Round-Hand #1½ nib. If using any other pen, check to see that the height is five times the width of the nib.

Legibility first, which begins with strong and well-proportioned letters. Balance is basic, within each letter, word, and page of writing.

Use this guidesheet with a Mitchell Round-Hand #2 nib. If using any other pen, check to see that the height is five times the width of the nib.

Use this guidesheet with a Mitchell Round-Hand #2½ nib. If using any other pen, check to see that the height is five times the width of the nib.

Use this guidesheet with a Mitchell Round-Hand #3 nib. If using any other pen, check to see that the height is five times the width of the nib.

Consistency of letter proportion, slant, and spacing contribute to both legibility and beauty. Beautiful writing also has a sense of life, freedom, movement, strength, flow, and personality, which come only after much practice with basic, simple letter models.

The aim of almost all calligraphic work is to create well-balanced compositions that express the meaning or mood of the words.

Use this guidesheet with a Mitchell Round-Hand #3½ nib. If using any other pen, check to see that the height is five times the width of the nib.

Use this guidesheet with a Mitchell Round-Hand #4 nib. If using any other pen, check to see that the height is five times the width of the nib.

Use this guidesheet with a Mitchell Round-Hand #5 nib. If using any other pen, check to see that the height is five times the width of the nib.

Use this guidesheet with a Mitchell Round-Hand #6 nib. If using any other pen, check to see that the height is five times the width of the nib.

V

Capitals

ROMAN AND ITALIC CAPITALS

Rather than invent a new set of capitals, the Renaissance writers of Italics borrowed the classic capitals that the Romans had brought to perfection by 100 A.D. Various versions were used along with the Italic minuscules—some simple, some elaborate, some upright, some slanted.

The skeletal forms of the letters, which you probably learned as a child in school, illustrate the essential features: horizontal, vertical and angled lines, as well as nearly circular shapes. Strong and well-balanced forms result when the letters are given their correct proportions.

The basic forms of this alphabet evolved over many centuries, and by 1500 B.C., the Phoenicians were using a version of it that was later handed down to the Greeks. The early Romans borrowed the basic alphabet, modifying it somewhat, as had the Greeks, and brought the letters to their ideal forms and best proportions. While Roman everyday handwriting based on these forms was often sloppy and careless, as ours is today, utmost care was taken when carving the letters into the many stone monuments erected in the first and second centuries A.D. Obviously, the very slow process of carving encourages much greater care, planning and attention to detail. A modern interpretation of the stone-carved Roman capitals is shown here, by Frankie Bunyard of Boston.

Some believe that compasses and rulers may have been used as aids in creating the stone-carved letters, although this is not known for certain. It is generally agreed upon, however, that the letters were first written with a brush onto the stone by the Romans before carving. The brushstrokes naturally end with a finishing stroke, or "serif," which was imitated by the stone carver, and in turn, later imitated by scribes when writing these letters with the pen.

The pen *may* create forms quite similar in appearance to those carved in stone, yet this can be a slow process in itself. Such letters may be written with an edged pen, and are also sometimes done by outlining the forms and filling them in with a pointed pen, a lettering technique of "building-up" akin to the carving process itself.

Shown here is a version of pen-made capitals, written with serifs. These letters are written with a changing rather than a constant pen angle, more closely approximating the stone-carved letters, as is the case with the quote written out by Jerry Kelly on the last page of this chapter.

Two very simple versions of capitals are presented for your study in this chapter—one slanted, one upright, without serifs, and with a constant pen angle—in the belief, as with the small letters, that once very basic forms are mastered, variations may be more successfully attempted.

The most important thing to be aware of in learning the capitals is correct proportions. The width-to-height ratios are very important, and the best way to get a sense of this is to relate each letter to a square. Some letters are just slightly wider than a square, some are just about a full square in width, some are nearly three-quarters of a square, and others are half-a-square wide. These proportions are demonstrated on the letter-model page of upright capitals, and the facing guidesheet should be very helpful in enabling you to figure out exactly how wide each letter should be. The proportions do change somewhat when the letters are written at a slant, but should still be kept in mind.

The pen angle will be different for the capitals. A 30° pen angle works better with the shapes of these letters. Use the dotted diagonal line at the top of each page to check your pen against. Do be sure, however, when going back to the small letters, that you return to the crucial 45° angle.

Although the stone-carved Roman letters were often the equivalent of ten or eleven pen-widths in height, the capitals here are about seven-and-a-half pen-widths high. When written along with the minuscules, they should *not* be the same height as the ascenders, but rather three-quarters their height, or one-and-a-half times the height of the letter bodies, in order not to overpower them. As you practice the capitals in this chapter, use the same pen size that you used

Skeletal Forms of Capitals.

ABCDEFGHIJKLMN
OPQRSTUVWXYZ

Alphabet Stone,
Frankie Bunyard.

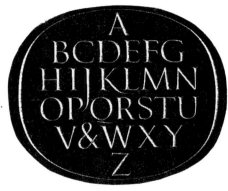

Formal Roman Capitals with Serifs, Jerry Kelly

ABCDEFGHI
JKLMNOPQ
RSTUVWX
YZ&JUWW

when first practicing the small letters in the Fundamentals chapter.

Proceed as you did with the small letters. Tracing will be very useful at first. Read the notations carefully. Go slowly. Write out some words and sentences after going over the letters individually. The same "rules" for spacing apply here. Aim to achieve balanced letters, that will combine into balanced words and sentences.

Be especially careful not to crowd the capitals closely together. Give them room to breathe; their inherent strength and energy cannot come across if they are cramped.

These letters may seem difficult, but don't be discouraged. Just keep working at it. There really is no substitute for practice.

The very first printed book on lettering, the *Alphabetum* of Damianus Moyllus of 1480, was an analysis of the Roman capitals. Countless authors since then have been fascinated with these seemingly ideal letterforms, and have written many books analyzing them, geometrically and otherwise. Do take a look at some of these books, especially those listed in the bibliography. One really could spend years doing nothing but studying and practicing the Roman capitals.

59

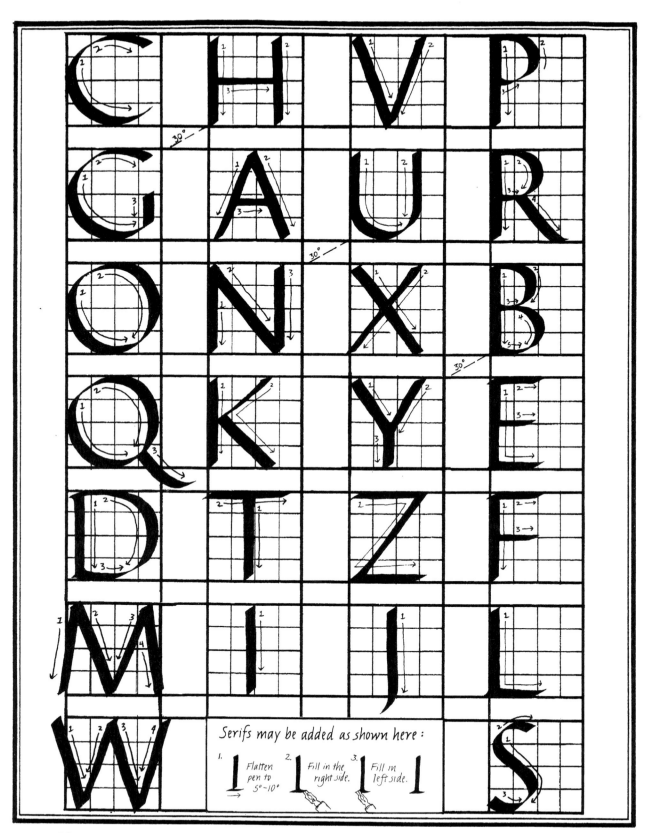

Serifs may be added as shown here:

1. Flatten pen to 5°~10°
2. Fill in the right side.
3. Fill in left side.

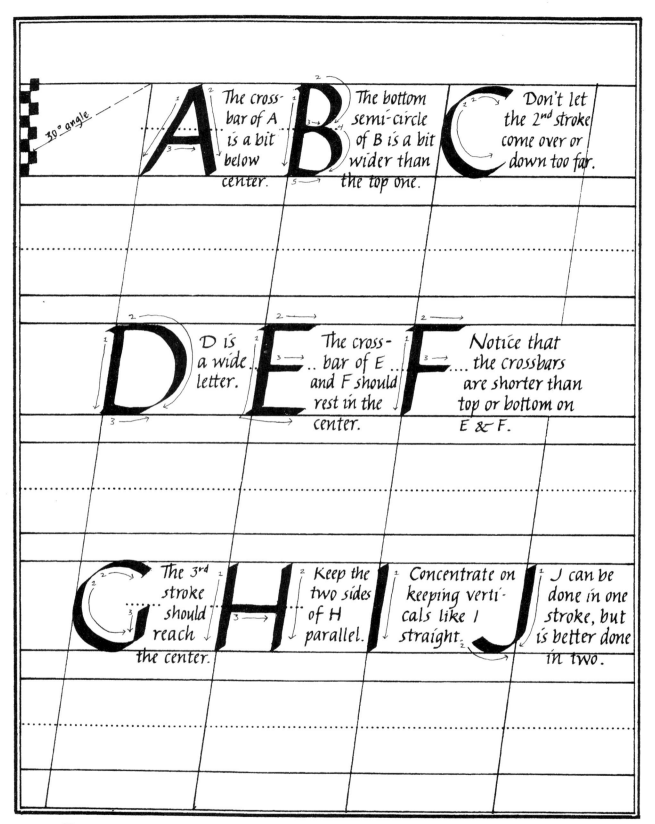

30° angle

A The cross-bar of A is a bit below center.

B The bottom semi-circle of B is a bit wider than the top one.

C Don't let the 2nd stroke come over or down too far.

D D is a wide letter.

E The cross-bar of E and F should rest in the center.

F Notice that the crossbars are shorter than top or bottom on E & F.

G The 3rd stroke should reach the center.

H Keep the two sides of H parallel.

I Concentrate on keeping verticals like I straight.

J J can be done in one stroke, but is better done in two.

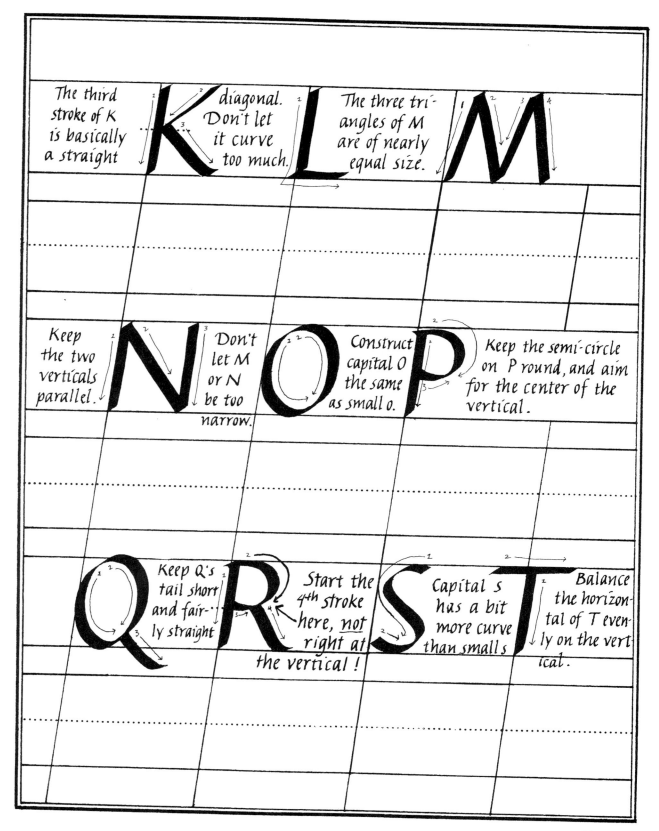

The third stroke of K is basically a straight

K diagonal. Don't let it curve too much.

L

The three triangles of M are of nearly equal size.

M

Keep the two verticals parallel.

N Don't let M or N be too narrow.

O Construct capital O the same as small o.

P Keep the semi-circle on P round, and aim for the center of the vertical.

Q Keep Q's tail short and fairly straight

R Start the 4th stroke here, not right at the vertical!

S Capital S has a bit more curve than small s

T Balance the horizontal of T evenly on the vertical.

63

30° angle for capitals

U

2/3

Start the
curve to
the right ⅔
way down.

V

capital
v + w are
best made in
several strokes.

W

X

like
small x,
cross at
center.

Y

The "v"
shape of Y
reaches be-
low center.

Z

z is the
same as
small z.

Use this guidesheet with a William Mitchell Round-Hand #1 nib. If using any other pen, check to see that the height is five times the width of the nib.

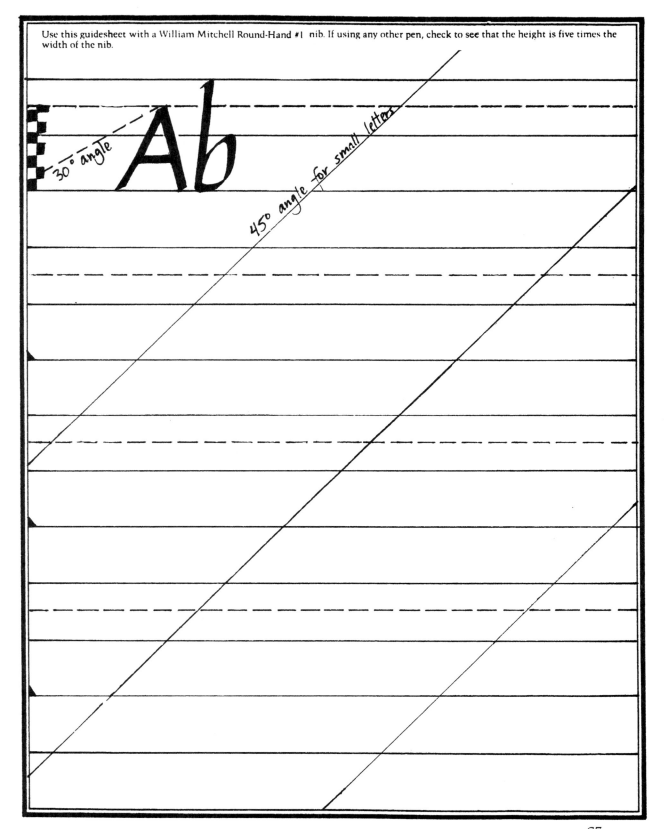

NULLUS
ARGENTO
COLOR EST
AVARIS AB·
DITO TERRIS
INIMICE LAM·
NAE CRISPE
SALLUSTI
NISI TEMPE·
RATO SPLEN·
DEAT USU

Jerry Kelly

VI

Variations

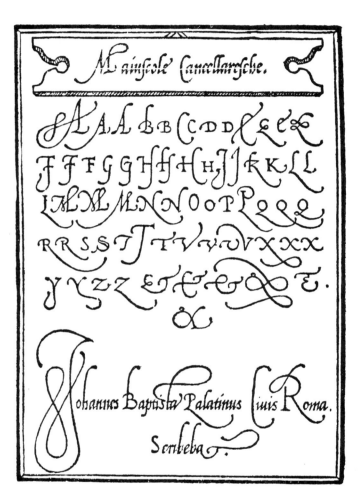

INFORMAL VARIATIONS

Some people have a normal handwriting that is both fairly legible and pleasing, and wish to study calligraphy simply as an extension of the use of the pen.

Most people, however, would admit that part of the attraction of the study of calligraphy comes from a dissatisfaction with their regular writing and a desire to find a way somehow to alter it.

After learning a slow, carefully formed Italic style, you may very well develop a fast, informal version for everyday use, and allow it to replace the script you have probably been using all your life. The script that is taught in most schools today is, after all, ultimately derived directly from the Italic letters, as discussed in the History chapter of this book, and shown in the chart tracing the development of Italic from the fifteenth to the nineteenth centuries. As the style evolved, the significant changes were the addition of loops, the joining-together of *all* letters within a word, and the change-over to a pointed rather than an edged pen. It is true that it is slightly faster to produce loops rather than to lift the pen, and not allow loops to happen. The time difference, however, really is extremely slight, and the gain in legibility is well worth the extra few seconds necessary. To a large degree, the presence of loops in regular script detracts from legibility, especially when they become large and exaggerated. Also, when many but not all letters join together within a word, legibility is gained. As for beauty, there can be no doubt that the contrast of line quality created by the edged pen is far more attractive than the monotonous quality of a ball-point pen or a pencil.

On the facing page is a demonstration of what happens when you begin to change from a slow to a fast version of Italics. Several changes occur when writing faster. The basic forms of the letters, which are so important when writing slowly, will begin to deteriorate to some extent. Some letters will begin to join together as well. The idea is to allow your hand to move freely and to let whatever happens naturally to occur. Some letters, especially those that end in the short diagonal, will easily join into their right-hand neighbors. Sometimes those letters that have crossbars, such as f and t, will also join the next letter. Other letters simply don't have a logical way of joining with their neighbors.

Spacing between words and letters will usually alter somewhat as the pen moves rapidly along. Often more space is left between words, as the hand jumps from one to the next.

In order to develop a fast, free Italic, spend a few practice sessions in the following way. Begin by taking a paragraph, using a small pen size, and write it out very slowly and carefully. Then write it out again, this time going a little faster. Write it out a third, or even a fourth time, building up speed until you are writing at almost the same speed as in your normal handwriting. Examine your results. See where the letters have joined together, if the spacing has altered, how the letterforms have changed.

Your fast versions should have a sense of life, energy, freedom and movement. If you compare them with your slowly and carefully written Italics, they probably won't look nearly as good to you, at first. However, if you compare your fast Italics with your *regular* handwriting, most likely the Italics will look far more attractive. Continue to be very aware of the difference between formal and informal Italics, though, and do remember to pay attention to all the details again when you are writing something in a formal version. The range between formal and informal, slow and fast, is, of course, vast, and there are all levels in between, which will be appropriate for different occasions.

Informal Italics will look better if done with an edged pen, yet it certainly can be done with a regular pen or pencil as well, and will still look attractive. Fountain pens and edged markers may be more convenient tools for informal writing, since they can easily be carried around, unlike dip pens, and used on all occasions.

This shows what happens when a slow, formal italic is written more and more quickly and finally becomes a free, informal style.

When writing faster, several changes occur. The letters begin to deteriorate to some extent, and some letters naturally begin to join together. The letters that end in a short diagonal, such as a, c, e, i, l, m, n, and u most easily join into their right-neighbors. Spacing between words will also become wider as the hand moves rapidly along.

FORMAL VARIATIONS

Some of the many possible variations of ascenders, descenders and flourishes are shown here. Practice these by first tracing them over with the appropriate pen size, and then trying them on your own. As you begin to experiment with variations, remember that one of the greatest factors contributing to beautiful writing is a sense of consistency. Consistency of letter proportions, slant and letter- and word-spacing throughout a given page is the most important factor. Consistency does *not* mean that exactly the same types of ascenders and descenders should be used throughout a page. It does mean, however, that it is best to use only a few different types of endings for the letters, especially those that compliment each other, within a given piece of calligraphy. If you look at the variations presented here, you will see that they give different feelings to the letters. Try to use ascenders and descenders that seem to have a similar feel to them, so that a unified mood will be present in your work. Some variety, of course, creates interest. Variety, or use of contrasting elements, must be kept simple, however. Too much contrast of any sort, including variations on the letters themselves, can create a feeling of "busy-ness" that detracts from both legibility and the overall effect.

Some variations include flourishes. These are natural extensions which grow out of, but do not alter in any way, the basic forms of the letters! They should be used very sparingly, especially at first. One or a few well-done and carefully placed flourishes can be far more effective than a page crammed full of them. Flourishes may be simple or elaborate. Sometimes they are done all in one stroke, and occasionally they may work best when executed in several strokes.

It's very important to keep a sense of balance in mind when using flourishes. When a rightwards flourish occurs, it is very often balanced out by a leftwards flourish, somewhere on the page, although not necessarily on the same word or line of writing. Aim for a sense of life, energy and movement in your flourishes. As with the letters themselves, this will only come with practice.

Several versions of "Swash" capitals are shown in this chapter. These letters must be used as initial letters *only*, along with the small Italic letters; but almost never in the form of whole words, which would be illegible.

Legibility is stressed throughout this book, for in most cases the words and their meaning are very important in calligraphy. Sometimes, however, letters simply form the basis for abstract designs, and in rare cases, the overall effect of a piece of calligraphy is more important than the words. In such cases, legibility may be sacrificed. Be sure, though, that illegible work is always the result of a conscious and fully appropriate choice, rather than due to carelessness or misuse of letterforms.

Two commonly used letter variations of small *t* and *g* are shown in detail below. On the facing page, you will also notice a set of "Old-Style" numbers, that is, numbers that are written at various heights, rather than all sitting on the baseline. Many calligraphers prefer this variation on numbers.

Variations

a b b d d d d e ff f

g g h h k ll m nn p

p p o s tt s t s t u v w x

y y y y y y y z

1234567890

Swash Capitals

ABCDEF

GHIJKLM

NOPQRST

UVWXYZ

Arthur Baker

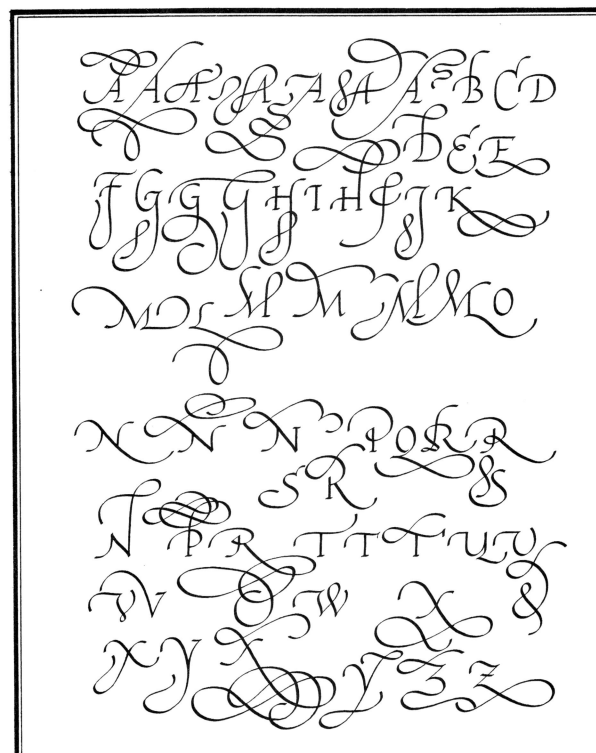

Paul Shaw

VII

Design

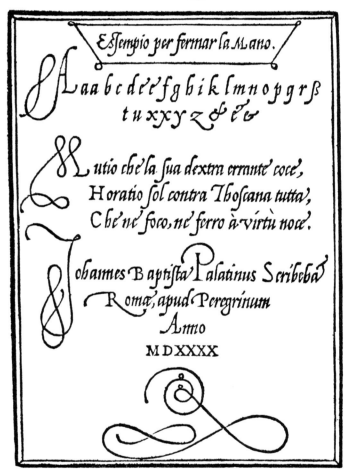

GENERAL DESIGN CONSIDERATIONS

Legibility and beauty are encompassed in the overall aim of calligraphic work, which is nearly always this: to create well-balanced compositions that express the meaning or mood of the words through appropriate use of lettering and contrasting elements.

A well-balanced composition has adequate margin space, as discussed and shown in the chapter on spacing. The margins should act as a frame to the text. Side margins should usually appear to be equal. What this means is that the text is vertically balanced, with equal weight falling on both sides of the page. There are five possible layouts for a page, as shown below. In *Figures 1* and *2*, the longest lines of the compositions are centered, and so a sense of balance is created. In *Figure 3*, all lines are centered. *Figure 4* is a composition that has all lines of equal size. *Figure 5* is an asymmetrical composition, but even in this case balance is achieved by keeping even weight on both sides of the vertical. In the case of a two-page spread such as a book, margins will be slightly different, so that the combined middle margin (gutter) of the two facing pages looks about the same as each side margin. Balanced pages, then, are simply a matter of planning and effectively using the space on a page. Do keep in mind that the bottom margin should almost always be greater than top or sides, in order to support the weight of the whole composition.

1. Flush left. 2. Flush right. 3. Centered. 4. Justified right and left. 5. Asymmetrical.

Expressing the meaning or mood of the words is really the whole purpose of calligraphy, in most cases. One of the first considerations is the type of lettering to be used. If you later go on to learn other styles, you will, of course, have more choice in this respect. Certain types of lettering styles seem indicative of a certain time, place or mood. You needn't feel restricted, however, even if Italics is your only choice. Italics is truly a versatile alphabet, and can be made to look a number of different ways to suit different purposes. As shown in the Spacing chapter, varying the linespacing can alter the texture of the page, creating different effects. As illustrated in the last chapter, many variations on the letterforms, especially of the ascenders and descenders, are possible. Letter proportions can sometimes be altered as well, if done consciously for a specific reason. You may at times want a heavier-looking letter, and can change the letter height to four rather than five pen-widths. You may want a thinner look, and can try writing at a six-pen-width height. Try this out by writing on guidesheets both smaller and larger than the normal pen size indicated, and get a sense of what happens. Italics can look informal or formal, very plain and austere, or very ornamental. The meaning or mood of the words should always be matched to the particular treatment of the letters, however, in any given context. Always think of the purpose of the work, what it will be used for—which is closely related to the meaning of the words.

Effective use of contrasting elements can help express the meaning or mood of the words as well. You may decide to pick out the most important words, phrases or initials and give them

Contrast of size | Contrast of weight | Contrast of STYLE

Contrast of color | Contrast of positioning | Contrast of lettering to border or illustration.

emphasis to make them stand out and create interest in your composition. There are six basic different types of contrast, as shown here.

One, quite simply, is contrast of size. Writing one or several words in a larger size is often the best way to give emphasis. Second, there is contrast of weight, which means writing out some of the words at a proportionally heavier pen-width than others. Often words written with a heavier weight are also written in a larger size, to give even more dramatic contrast. Third, there is contrast of style. You may choose to write some words out all in capitals, along with other words written in minuscules. Do remember to only use simple capitals as whole words, however, and *not* swashed or flourished capitals! By using different colors of papers and ink, you may create a contrast of color. Refer back to the Tools and Materials chapter for specifics on this. Do experiment with color. Even in the early stages, color can add much life and excitement to your work, and may well be used to express a certain mood. A fifth type of contrast is contrast of positioning. There are times when placing words in unusual positions can add a pleasing decorative effect. The last type of contrast is a contrast between the actual lettering and any other decorative elements that are used along with it, such as illustrations, borders, etc. Simple line borders can be created with technical pens or just thin pointed black or colored markers. Many books of border and other designs and illustrations are published, which permit use without specific permission. These books may simply give you ideas, or you may photocopy, cut out and paste up the actual designs from them if you are creating a piece for reproduction. In any case, borders or illustrations should always be complementary to the lettering, by having a similar weight and feel to them.

It is suggested that you spend some time copying out the exercises showing different types of contrast, to get a sense of the possibilities. Contrasting elements should be used in harmony with each other, however. Keep your compositions simple. Only emphasize words where such emphasis makes sense, and don't allow too much competition between elements. One strongly emphasized word or line can be offset with other less dramatic elements, but there should be only one truly dominant element on the page.

Study the calligraphy in the last chapter of this book. Get a sense of how balance is at work in these compositions, as well as how the meaning or mood of the words is expressed, and what sorts of contrast are used. Become an observer. Lettering design is to be found on book covers, in magazines and newspapers, record jackets, on signs in stores, etc. Get ideas and inspiration from what others have done. Do take a look at the anthologies of contemporary lettering listed in the bibliography of this book. One excellent way to learn is to find a piece that really inspires you and to try to copy it as closely as you can. In this way you will realize just how the particular effects were created, and you can apply this knowledge to your own calligraphic work.

TEN BASIC DESIGN STEPS

The ten steps below may be followed in all calligraphic projects. Careful planning can often save much time and effort, and reduce the possibilities of making mistakes. You may decide to eliminate some of the steps outlined, of course, or to alter them in any way that you find works best for you, but they will be helpful as an initial guide. Read this over, and then try applying these principles to the creation of an envelope, invitation, sign, poster, poem or any other project.

Step 1. Decide just what it is you want to create, and whether it will be one original piece or whether you will have it printed or photocopied. Keep in mind the function of the piece at all times. Decide what size you want the final piece to be. If you plan to frame it, try and use paper that will easily fit a standard-size frame.

Step 2. Plan the exact wording, and study the words to see how they might best be expressed. Try and get a sense of what size pen you will use to best fit the wording onto the paper. Determine which words are most important, and whether you want to give special emphasis to any particular initials, words or phrases. Remember, keep it simple. Only one word or line should be truly dominant, while others can be emphasized to a lesser degree.

Step 3. Make three or four very rough sketches in pencil, using different contrasting elements, of possible layouts. Include in rough form any borders or other decorative elements that you may want to use, remembering to keep them in harmony with the lettering.

Step 3. Make three or four rough sketches in pencil.

Step 4. Make a full size rough draft in pencil.

Step 5. Write out all lines in ink on a *preliminary* version.

Step 6. Rule lines on your final paper with a T-square, unless you are using guidesheets.

Step 7. Cut out each line of writing from your preliminary version, and fold it in half.

Step 8. Unfold the lines. Use them as a guide to spacing by writing out the words underneath in pencil on your final paper.

Step 9. Go over your pencil version in ink, adding in final form any illustrations, borders, etc.

Step 10. Erase all pencil lines with a good, soft eraser.

Step 4. Select the design that seems best, and now make a full-size rough draft, still in pencil. Keep in mind a sense of balance, provide adequate margins, and decide whether you will use tight, wide or normal linespacing. Figure out exactly what size letters you want to use, and just where they will be on the page. Again, in rough form, include any borders or other decorative elements to appear in the final version.

Step 5. You are now ready to write out your lines, in ink, with the pens that you will be using for the final version. This is only a preliminary version, however, so use plain white bond or even tracing paper over a guidesheet of the appropriate size. Write out each line, paying special attention to letter proportion, as well as letter- and word-spacing. Make no attempt to center the lines, however. It helps to make a straight line along the left side of the page, and begin each line of

writing there, on this preliminary version, in order to force yourself to avoid attempts to center the lines.

Step 6. While waiting for this to dry, take out the sheet of paper that will be your final version (cut it to size, if necessary). In most cases, you will need to rule your lines onto this paper with a T-square. (If it is thin paper, however, and if you are using normal linespacing, you may end up just using the guidesheet underneath this paper.) Follow this procedure: first, in very light pencil, put a line down the vertical center of the page. Then, either measure with a ruler the correct line-heights and mark them off on the page along the vertical line you have just drawn, or transfer them directly from the correct guidesheets. Your paper should be taped down to the table with masking tape, lined up straight against the edge. Ride the T-square against the edge of the table, making sure the top of the page is lined up correctly with it. Rule your lines across with a light pencil, making sure that the T-square is held securely with your other hand and does not move, so that the lines will really come out parallel with each other. You will then have a fully-lined page, ready to use, and it will be helpful if you put a small "x" on each line that you will be writing on, in order to avoid accidentally using the wrong line. If you remove the masking tape gently, it will not damage the paper.

Step 7. Now go back to the page on which you wrote out each of the lines in ink. Take a sharp pair of scissors, and cut out each line of writing from the paper. Then fold each line in half so that the ends of the letters match up evenly. Hold it up to a light so that you can really see this. Crease the lines along their centers, then unfold them.

Step 8. Your goal here is to create a balanced composition. If your composition is going to be flush left or flush right, unfold the *longest line only* and lay the crease along the vertical center-line of the page. You may now mark off the right and left margins, with a ruler or triangle, and they will be equal. If the composition is flush left—that is, aligned with the left margin—you may go ahead and lightly write out each line in pencil. If, however, your composition is going to be centered, you will take each line, and either hold it with your left hand or lightly tape it to the paper, several lines above that on which it actually will appear. Using this as a guide to perfect spacing, write out the words directly below, on the proper line, in pencil. All your lines will be perfectly centered in this way. If your composition is asymmetrical, it is still important that it be balanced on the page, so place the lines in the positions that you want them, still leaving equal side-margins, as with a flush-left composition. Then write them out in pencil.

Step 9. Now go over your pencil version in ink. Most people find this works well, but some find it awkward. If you do find it to be a problem, simply follow the above steps, writing directly in ink rather than in pencil. At this time, also, add any borders or illustrations with pen, ink, paint, markers, etc. You may wish to try a simple line border, using two pointed markers of varying weights to create a contrast of line quality and a more interesting effect. While working on a piece, continually move your paper up so that your line of writing is always directly in front of you.

Step 10. Wait until the ink is absolutely dry! Then erase any pencil lines with a good, soft eraser, rubbing gently, in only one direction. A dustbrush can be useful in removing any eraser crumbs. Your composition is now complete. A final step, where appropriate, could be to add a frame or mat of a color harmonious with the rest of the composition.

After completing any composition, prop it up against a white background, step back and take a good look at it. Ask yourself the following questions to see if you have really achieved the results that you want.

1. Does the page look well-balanced? 2. Are the margins adequate? 3. Is the meaning or mood of the words expressed well? 4. Have contrasting elements been used effectively? 5. Is there a feeling of overall harmony? 6. Is only one element truly dominant on the page? 7. Are the eyes first attracted to the lettering rather than to empty white space? 8. Is there a feeling of life and energy present?

Sometimes you will be happy with your first version. Other times you may have to do it over several times until it seems satisfactory to you. Be critical of your work, but at the same time *always appreciate the pleasing aspects of it as well!* Do not expect perfection. Because every piece of calligraphy could be written out in numerous different ways, you will almost always wish you had done something just a little differently. This will be the case once your work is on an advanced level just as much as in the beginning, if not more so. After you are more experienced, you will be better able to estimate length of words and lines ahead of time, and so preparation time may be greatly reduced. The more planning, though, the less likelihood of mistakes. Since we are all human, mistakes will sometimes happen no matter what care has been taken. Don't despair; most mistakes can be dealt with. If you have misspelled a word or omitted a letter, you might simply consider lightly crossing it out, and, with a smaller pen, writing in your correction above. This is acceptable in some cases, and is certainly to be found in abundance in the illuminated manuscripts of medieval scribes. You may also try covering up the error in white-out or paint, the color of your paper, and going over it. Alternatively, you may take a small scrap of the same paper, rewrite the word, and paste it in on top of the error. Professional draftsman and calligraphers sometimes use electric erasers, a powerful tool that can remove ink very well from many (but not all) papers without a trace. Art supply stores sometimes sell small, inexpensive models of these erasers, and they are worth trying. It is true, of course, that when a piece needs to be absolutely perfect, sometimes an error is too large to remedy, and the whole piece will have to be done over. If so, just try to think of it as an opportunity to do an even better job on the next one.

If the piece is going to be reproduced, mistakes can be retouched with white paint and a brush. Whenever retouching letters, however, always use a pen smaller than the one originally used. Lettering and decorative elements can be moved around easily and pasted down with rubber cement on pieces to be printed. Non-reproducing blue markers or pencil can also be used to make lines on work for reproduction, since this does not show up in the printing process. It is also a good idea to make the original work somewhat larger than the finished piece will be. It can be photographically reduced by the printer's stat camera, and will give better contrast and line quality than you can get when working with a small pen-size. Some photocopy machines can do reductions as well, although they will not be of as high quality. Do make use of your local copy center. Colored papers and photocopying can be a very good and inexpensive substitute for offset printing when producing posters, signs, etc.

Do take a course in basic graphic design procedures, however, if you are going to concentrate on calligraphy for reproduction. There is much more to learn than can be covered here. The possibilities in calligraphic design are endless. There is always something new you can try. Let your imagination run free. There is a wealth of creativity in all of us, which is just waiting to be released. Take every opportunity to experiment. Even a mundane envelope can be an exciting design project, and one that will delight the recipient of it as well as the post office workers!

VIII
Examples

Love fills a lifetime
and a lifetime begins this hour~
~when the two of us
Margaret Mary Wengler
&
Mark Alan Cordova
begin our new life together
Saturday, the twentieth of October
Nineteen hundred and eighty-four
at eleven-thirty in the morning
Christ Lutheran Church
300 Hillside Drive South
New Hyde Park, New York

Jerry Kelly

Ronnie Solomon, & Michael Maddalena
invite you to join them while they marry
Sunday, April 15, 1984
The Tower Suite of the Time-Life Building
Avenue of the Americas
at 50th Street, in New York City
at 12 o'clock noon, 47th floor

Cocktails and reception immediately
following the ceremony

Marcy Robinson

Give Thanks

Paul Shaw

The
1986
N.C.Wyeth
CALENDAR

Jeanyee Wong

Paul Shaw

Grand
Awards
Banquet

The
LIBRARY
Company

Marcy Robinson

Round the cape
of a sudden came the sea,
And the sun looked
over the mountain's rim:
And straight was
a path of gold for him,
and the need
of a world of men
for me. ROBERT BROWNING

Jerry Kelly

84

Frankie Bunyard

A Fable by Richie Tankersley Cusick

With an Afterword by Rick Cusick

Ink & Paper

Nyx Editions · 1984

ITALIAN

Who hath not courage needs legs.

Rick Cusick

Each person's journey
involves both unique
circumstances and a
common map. My
particular path is only
a variation of a way
that is universal.

SAM KEEN

David Mekelburg

AABBCDEFGHIJ
KLMMNNOPQR
RSTUVWXY&Z

David Mekelburg

AAAABBCCDDE
EEFFFGHHIJIJKK
LLLLMMMNNOP
PPQQRRRRSSTTU
UVVVWXXYYYYZZ

David Mekelburg

88

10th EISTEDDFOD

southeastern massachusetts university eisteddfod traditional arts festival

friday 8pm	saturday 8pm	sunday 8pm	children's concert
Roy Harris	Spaelimenninir'	Johnny Cunningham	Bruce Hutton
SS Sacrament	I Hoydolum	Barbara Carns	Sandy & Caroline Paton
Martin Grosswendt	Rosalie Sorrels	Philippe Bruneau &	MA Samuels
Tríona Ní Dhomhnaill	Erik Ilott	Dorothy Hogan	Margaret MacArthur
with Mark Roberts &	The Clutha	Double Decker	
Claudine Langille		String Band	

free folk music workshops country dancing mini concerts free crafts fair

workshops with

Black Joker Morris Men • Allan Block
Ralph Bodington • Nacabarfeidh with
Patrick O'Gorman, Grier Coppins, Ian
Goodfellow, Dick Murai, Trevor Ferrier
Cape Verdean Folkloric Dance Troupe
Clanjamfrey with Pete Farley,

Paddy Riley, Mansk Grady, Joe Gerhard
clutha with calum Allan, Gordeanna
McCulloch, Erlend Voy, Ronnie
Alexander, Tom Johnstone • Jim Couza
Double Decker String Band
with Bruce Hutton, Bill Schmidt, Craig
Johnson, John Beam • Matt Fichtenbaum
Dan Georgianna • Paul Geremia • Tom
Gibney • Mark Gilston • Ken Goldstein·

Sara Grey • Cliff Haslam • Joe Heaney
Peter Hoover • Richard Hughes • Donna
Huse • Peter Johnson • David Jones
Norman Kennedy • Louis Killen • Leo
Kretzner • Rick Lee • M. MacArthur
Peter Marston • Jane McBride • Debby
McClutchy • Linda Morley • Kendall
Morse • Michael Moyes • Lisa Neustadt
Phil Binette, Eddie Bussiere, Bill Avery

Sandy & Caroline Paton • Robin & David
Paton • Maggi Peirce • Roaring Jelly
John Roberts • Jerry Rockwell & Mary
Ann Samuels • Irene Saletan & Ellen
Christenson • Tony Saletan • Walter
Scott • Joel & Kathy Shimberg • Lucy
Simpson • Joan Sprung • Dwayne Thorpe
Jake Walton • Jeff Warner & Jeff Davis
Vic Wotherspoon and many others •

Free Workshops-Fri 1-5, sat & sun 10:30-5
Free Country Dancing-Fri, Sat, Sun 5-6:30
Free Crafts Fair-Sat & Sun 10-5

Evening concerts-SMU auditorium
All event ticket $17. · Fri & Sun $6 - Sat $7
Free Parking

Children's Concert $1. · Sat 1 pm at the
Children's Museum Outdoors on
Old Westport Road · Free Parking

SMU students, faculty, staff, sr. citizens,
children under 12 - all event ticket $11.
Fri & Sun eve. $4 each, Sat eve. $5.

SEPT·25·26·27, 1981

all programs subject to change for information telephone 617-999-8166 SMU, North Dartmouth, MA 02747

Howard Glasser

+ Alleluia! + Alleluia! +

The Right Reverend
Frederick Hesley Belden
Bishop of Rhode Island
Acting for the Bishop of Newark
will Order the Reverend Donald Lorne Coyle
Priest in the Church of God
on December the fourteenth
Nineteen hundred & seventy-five
at eleven-fifteen in the morning
in Trinity Church
Newport, Rhode Island
+
Your prayers and presence are requested

Clergy: red stoles

Alexander Nesbitt

Pity me
that
the heart
is slow
to learn
what the
swift mind
beholds
at every
turn.
Edna
St. Vincent Millay 1923

Janet Parker

Zeal for excellence

Carol Anne Millner

Robert Boyajian

90

The first in time and the first in importance of the influences upon the mind is that of **Nature** Every day the sun; and, after sunset, Night and her stars. Ever the winds blow; ever the grass grows. Every day, men and women, conversing-beholding and beholden. The scholar is he of all men whom this spectacle most engages.

—EMERSON

Robert Boyajian

Disciplined freedom

Caroline Joy Adams

tiger lilies

Carol Anne Millner

JoAnne Valentine & Leigh R Powell were united in holy matrimony on the nineteenth day of August, nineteen hundred seventy-eight in the village of Patchogue NY

We are no other than a moving row
Of Magic Shadow shapes that come and go.

RUBÁIYÁT OF OMAR KHAYYÁM

Joanne Powell

92

True ease in writing comes from art, not chance, as those move easiest who have learned to dance.

Alexander Pope

Caroline Joy Adams

Leonardo da Vinci

Jerry Kelly

93

CONCLUSION

Congratulations on completing this book! You have now established a firm basis in the Italic hand, and as you proceed to become a more highly skilled calligrapher, my hope is that you will continually enjoy this immensely satisfying art form. And remember, the best thing you can possibly do with your calligraphic art is to give it as a gift—in whatever form you wish, be it beautifully addressed envelopes, personalized bookmarks, handmade greeting cards, or elegantly rendered poems or quotes—all with the goal of brightening the lives of those around you who will delight in your work. Through the art of beautiful writing, then, may you enjoy your own creative capacities to the fullest—and be a spreader of light, beauty, and joy in this world.

And now that you are familiar with Italic, you may wish to go on and explore other styles as well. Some of my own favorite calligraphy books, which can help you continue your learning process, are listed in the bibliography on the facing page. There are also many other excellent books now available on the subject as well. Below, I have listed the following resources so that you may have access to the latest tools, materials, books, workshops, and related information.

HELPFUL RESOURCES & CALLIGRAPHIC WEBSITES

Paper and Ink Arts, 3 North Second Street, Woodsboro, MD 21798
Phone (800) PEN-7772 FAX (888) PEN-7773 Email: paperinkarts@aol.com

Paper and Ink Arts is simply the best resource in the country for calligraphers at all levels. They have a gorgeously produced full-color catalog that features just about anything calligraphic you could possibly want, from pens of all sorts to exquisite handmade papers, light boxes, books, and much more. Best of all, they carry my favorite brand of colored calligraphic magic-marker pens, Zig, which come in a wonderful array of colors, are made in Japan, and for some reason, are not carried by many art stores these days.

I highly recommend you give Paper and Ink Arts a call and get a copy of their wonderful catalog, for you are sure to find everything you will ever need for your calligraphy projects. (They also have a website, www.PaperInkArts.com, which makes it possible for you to see some of their offerings, although they prefer to have their customers order by phone or fax.)

www.SocietyofScribes.org
This is the website of the New York City-based organization, the Society of Scribes, which is one of the most open, friendly, and helpful calligraphic organizations anywhere. They have regular calligraphic exhibitions, offer a variety of workshops year-round, and always welcome new members. They also offer many links to other calligraphic organizations.

www.CarolineJoyAdams.com
This website shows my line of calligraphically rendered posters and prints, *Inspirations,* which have been sold in stores and direct mail catalogs since 1992. It also offers information about my own upcoming events and workshops, along with my books, *A Woman of Wisdom* and *The Power to Write,* which feature calligraphic quotes interspersed throughout the text.

Please feel free to send me an email at the following address if you would like to be in touch: caroline@carolinejoyadams.com. I will be delighted to hear from you and would love to know about your calligraphic progress, as well as other calligraphy websites, exhibitions, or related organizations.

SELECT BIBLIOGRAPHY

HISTORY OF CALLIGRAPHY—GENERAL
The 26 Letters. Oscar Ogg. Thomas Y. Crowell Co. 1964.
The History and Technique of Lettering. Alexander Nesbitt. Dover Publications. 1957.
A Book of Scripts. Alfred Fairbank. Penguin. 1955.
Writing, Illuminating, and Lettering. Edward Johnston. Dover Publications. 1995.
The Story of Writing. Donald Jackson. Taplinger Publishing Co. 1981.
History of Graphic Design. Philip Meggs. Van Nostrand Rheinhold. 1983.

HISTORY OF CALLIGRAPHY—ITALIC
Renaissance Handwriting. Alfred Fairbank. World Publishing Co. 1960.
Scribes and Sources. A. S. Osley. David R. Godine. 1980.
Andres Brun, Calligrapher of Saragosa; Some Account of His Life and Work. Henry Thomas and Stanley Morison. The Pegasus Press. 1929.
Three Classics of Italian Calligraphy. Oscar Ogg. Dover Publications. 1953.
The First Writing Book. J. H. Benson. Yale University Press. 1954.
Italian Typography of the Sixteenth Century. A. F. Johnson. E. Benn Ltd, London. 1926.
An Italic Copybook; The Cataneo Manuscript. Stephen Harvard. Taplinger Publishing Co. 1981.

ANTHOLOGIES OF HISTORIC CALLIGRAPHIC SAMPLES
The Pen's Excellence. Joyce Irene Whalley. Taplinger Publishing Co. 1981.
2000 Years of Calligraphy. Edited by Dorothy Miner. Taplinger Publishing Co. 1965.
Treasury of Calligraphy; 219 Great Samples, 1522-1840. Edited by Jan Tschisold. Dover Publications. 1984.
Penmanship of the XVI, XVII and XVIII Centuries. Lewis Day. Taplinger Publishing Co. 1979.

ANTHOLOGIES OF MODERN CALLIGRAPHIC SAMPLES
Modern Scribes and Lettering Artists. Taplinger Publishing Co. 1980.
Calligraphy Today. Edited by Heather Child. Taplinger Publishing Co. 1976.
International Calligraphy Today. Watson-Guptill. 1982.

INFORMAL ITALIC INSTRUCTION MANUALS
A Handwriting Manual. Alfred Fairbank. Faber & Faber Ltd. 1932.
Improve Your Handwriting. Tom Gourdie. A & C Black Ltd. 1984.
Handwriting For Today. Tom Gourdie. A & C Black Ltd. 1980.

CALLIGRAPHIC INSTRUCTION MANUALS FOR ADVANCED STUDENTS
Written Letters. Jacqueline Svaren. Taplinger Publishing Co. 1981.

ROMAN LETTERING
Roman Lettering. L. C. Evetts. Pitman Publishing. 1978.
A Constructed Roman Alphabet. David Lance Goines. David R. Godine. 1982.
The Origin of the Serif. E. M. Catich. The Catfish Press. 1968.

MISCELLANEOUS
Calligraphy and Paleography. Edited by A. S. Osley. Faber and Faber Ltd. 1965.
Edward Johnston. Priscilla Johnston. Taplinger Publishing Co. 1976.
Layout and Design for Calligraphers. Alan Furber. Taplinger Publishing Co. 1984.
Calligraphic Designs. Mimi Armstrong. Stemmer House, Inc. 1983.

Are we not driven to the
conclusion that of the things which
man can do or make here below, by far
the most worthy, momentous and wonderful
are the things called BOOKS ?

Thomas Carlyle

Caroline Joy Adams